IMAGES
of America

GRANTS PASS

On the Cover: This location of Zottola's Ice Cream Co. opened about 1946. The address was 812 Southeast H Street. Note the girls all have on dresses, the younger ones with bobby socks. Standing in the doorway is Paul Border, the ice cream maker.

Contents

Acknowledgments 6

Introduction 7

1. The Development of Downtown Grants Pass 9
2. Schools and Churches 53
3. Merchants 67
4. Activities for the Public Good 83
5. Transportation 97
6. Parades and Gatherings 117

ACKNOWLEDGMENTS

It should be acknowledged that there are more photographs than pages, and all the suggestions are appreciated, but not everything could be used. In the end, using just photographs from the files of the Josephine County Historical Society was the best way to approach the project. To the people who helped suggest photographs, some of which were used and others not, and assisted with computer glitches, thanks go to Kathy Marshall, Rick Marshall, Jean Boling, Martha Metcalf, Pat Heumann, Gary Swanson, Wendy Swanson, Rose Scott, and the Board of Directors of the Josephine County Historical Society.

INTRODUCTION

People settled in the vicinity of what is now Grants Pass long before it got named and even longer before it began to grow. The earliest settlers did not set up homesteads on the city site; instead they spread out around the region. Some of those settlers created small communities, some stayed and farmed on isolated land, and others were temporary inhabitants looking for gold.

In 1851, Joel Perkins and his wife, Laura Hawn, built a cabin along the Rogue River in the area now known as Fruitdale. Perkins built and operated a ferry across the river. Fruitdale is not a city, but a community of people on the south side of the Rogue River. It is often put on maps, and some may think it is a little independent town, but for the most part, it is the southeastern edge of Grants Pass. When Perkins built his ferry, the area came to be called Perkinsville, even though he and his wife only stayed about a year.

In 1852, Jackson County was established. It was a large county and encompassed what is today Josephine County. Oregon was a territory and had not yet become a state. Perkinsville was in the northern part of Jackson County, about midway from the east and west boundaries of the county. Perkinsville was the name of the Jackson County voting precinct in the area.

In 1851, gold had been discovered in the Illinois Valley, about 25 miles south of Perkinsville, and miners began to move into the area. This increased movement is one reason why Joel Perkins moved south from Yamhill County to settle along the Rogue River and operate a ferry. Also in 1851, a miner and his daughter discovered gold along a creek in the Illinois Valley. The local miners began to call the creek and the valley Josephine, after Virginia Josephine Rollins, the miner's daughter. The name of the creek remained, but the valley became known as the Illinois Valley.

In 1856, George Briggs, a representative of the territorial legislature from the Illinois Valley, was instrumental in having Jackson County split into two counties. Josephine County became the only county in Oregon to be named after a woman. However, in splitting the two counties, the legislature put an east-to-west line in the basic north-to-south county line that kept Perkinsville in Jackson County. And to this day, people wishing to trace their land rights in Grants Pass soon come to the realization that Grants Pass remained in Jackson County for almost 30 years after Josephine County was established. The records from 1856 to 1885 are at the Jackson County Courthouse.

In 1859, Oregon became a state, and the next year, a stage station was moved from the Jump-off Joe area to Louse Creek Station a few miles south, almost to the present site of Grants Pass. Grants Pass slowly began to grow with the new state. Perkinsville was a small community along the river, and the stage station was about four miles north. Post offices were established in Josephine County but not in Perkinsville. In 1865, a post office was established at Louse Creek Station along with the new name of Grant's Pass. The apostrophe was dropped at the turn of the century. The name of the Jackson County Perkinsville precinct was changed to Grant's Pass in 1868.

The plan was to name the town after Ulysses S. Grant, but Grant County, Oregon, had just been granted a post office, and the US Postal Service in Washington, DC, thought it might be

confusing, and thus Grant's Pass was the compromise. The town was named in honor of Grant's Union victory at Vicksburg, Mississippi. General Grant himself was never in Southern Oregon.

The settlement moved down the valley along the Rogue River after C.J. Howard surveyed the new site. On Christmas Eve 1883, the California & Oregon Railroad line reached Grants Pass. A railroad depot was built along the tracks right in the center of what is now Sixth Street. Grants Pass rose in stature as it became the railhead for the rest of the Rogue Valley. People had to come from southern and eastern Jackson County to use the train for shipping or passage. Businesses soon petitioned to have the county line adjusted to include Grants Pass in Josephine County.

The town began to grow. A group of education-minded businessmen bought the seldom-used Eureka Academy building at Jerome Prairie, seven miles west of Grants Pass, and reconstructed it in the downtown area in 1884. This gave Grants Pass a real school building, not a haphazard log cabin that not only served as school but also as a church and meeting hall. The next year, the county line was adjusted, and Grants Pass became the county seat. Both a courthouse and jail were built. A bridge was constructed across the Rogue River, and the first brick building was erected in 1886. Many traditional churches with tall bell towers were built throughout the platted area.

In the years following the arrival of the railroad, a new depot was built, which opened Sixth Street to through traffic. The Grants Pass Diversion Dam was built across the Rogue River, south of the bridge, and in 1889, electricity was locally produced. A large opera house was built on the corner of Sixth and F Streets, and soon the First National Bank of Grants Pass was built across the street. The wooden school was replaced by a two-story brick building with a daylight basement. The city was incorporated under the laws of the state of Oregon, and everything needed to properly run a city was established.

The railroad continued south to Medford and Ashland, and although no longer the local railhead, Grants Pass continued to grow. It grew to be the largest town in the county, providing supplies for the southern part of the region. The route of the railroad included Wolf Creek, Hugo, and Merlin, but no rails went toward the Illinois Valley.

Entrepreneurs began to explore the possibility of a railroad to Crescent City. The Oregon & California Coast Railroad was formed but it was short lived. Its rails only extended to Waters Creek, just past Wilderville, and were less than 15 miles in length.

Agriculture and mining in Josephine County helped Grants Pass continue to grow. Mining began to fade with World War II, and the lumber industry began to expand. There were many forests to harvest for timber; however, that too began to wane in the latter decades of the 20th century. Tourism grew and continued to flourish, and Grants Pass became the "jumping off" site for recreational use of the Rogue River. Many lumber mills closed, and agriculture and mining were pursued by few. Grants Pass has reached about 25,000 in population, and the largest single employer is the school district. Many people who grew up in Grants Pass in the 1950s and 1960s but left for higher education and/or better jobs returned in retirement along with many others who "found" the area and also opted to retire in Oregon. But even the newcomers can see what Grants Pass looked like 100 years ago because many of the business buildings have been preserved.

This book covers the time from the first photograph in 1883 to the 1960s.

One
THE DEVELOPMENT OF DOWNTOWN GRANTS PASS

When the railroad arrived in Grants Pass on Christmas Eve 1883, there was not much that resembled a town. The street parallel to the railroad tracks was called Front Street because it "fronted" the railroad. Many of the first businesses opened on Front Street, with a wooden facade in the front but a tent in the back. Some of the early settlers in the town opted for pitching a tent and calling it home until they could see if they would "make it" in the community.

Just prior to the arrival of the railroad, Jonathan Bourne, a lawyer from Portland, purchased several properties north of the Rogue River and had a townsite survey done to correspond with the rail survey so that the streets ran parallel and perpendicular to the tracks. On old maps, this is referred to as Bourne's Original Townsite. Bourne was later elected to the Oregon House of Representatives (1885–1886) and served as a US senator from Oregon (1907–1913), but never lived in Grants Pass.

Solomon Abraham, who was an agent for the California & Oregon Railroad and lived in Grants Pass, took over an earlier filed plat site that did not follow the railroad tracks but went geographically east and west. Abraham's site was known as the Railroad Addition.

The result of two different filings is the reason why all the streets along G Street west of the original brewery run diagonally off of G Street to the west and at 90-degree angles to the south. Solomon Abraham was of Hebrew ancestry and his development was referred to as Jerusalem. Few businesses chose the Railroad Addition and opted to build in the original townsite. The Railroad Addition extended south to a street now called Western Avenue. Western Avenue was the county line between Josephine and Jackson County, placing Grants Pass in Jackson County. While Bourne was serving in the Oregon House of Representatives, the county line was changed, moving five miles east to the approximate location of Savage Rapids and including Grants Pass in Josephine County.

Soon after the railroad arrived, Grants Pass became the county seat for Josephine County, and Solomon Abraham moved north and founded a small town named Julia, after his wife. Today, Julia is named Glendale, Oregon.

This chapter deals with the development of the business district of Grants Pass from its 1883 beginnings to the 1950s, with more toward the beginning and less from more modern times.

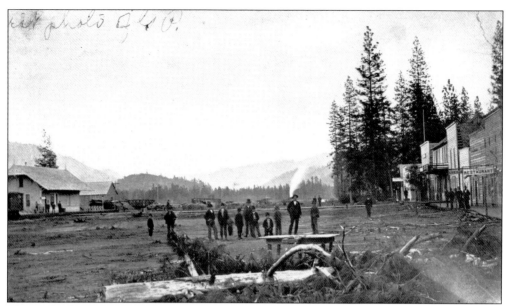

This is the first photograph taken in Grants Pass around 1883. The men and boys are standing in the middle of G Street, then called Front Street, between Fifth and Sixth Streets. The newly constructed buildings on the right constitute the first businesses in town. The buildings, all constructed of wood, faced the railroad tracks, which are to the left of the photograph.

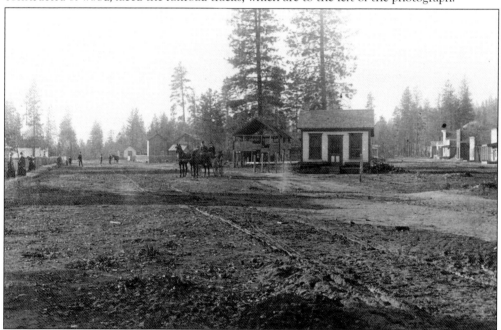

In the late 1880s, about three blocks west of the railroad station, the town's grid system veered. G Street turned to run directly west instead of being aligned with the portion of G Street running parallel with the railroad tracks. Foundry Street, where the buildings are in this photograph, ran parallel to the tracks. This section was founded and surveyed by Solomon Abraham, and the portion that ran parallel to the tracks was founded by Jonathon Bourne. Abraham lived in Grants Pass; Bourne never did.

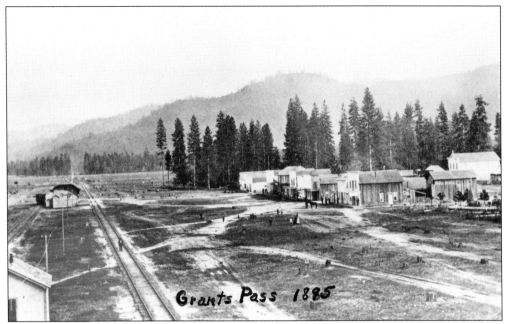

In 1885, the first little train depot for Grants Pass sits in the center of Sixth Street. Walking paths across G Street (Front Street) were trampled into place by pedestrians. On the right side of the photograph, the roadway forks to the right to the business district and to the left to the railroad station. Telegraph lines can be seen along the tracks to the left between the two sets of rails.

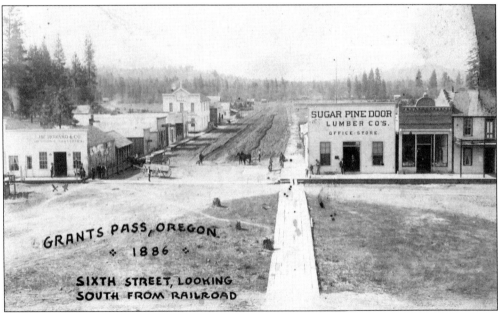

By 1886, wooden sidewalks had been built along G and Sixth Streets. Some of the tree trunks still needed to be removed. Even though it was no longer the railhead since the railroad line had extended to Medford, Grants Pass was growing and still served as the major railroad loading point for all of southern Josephine County, including the Illinois Valley.

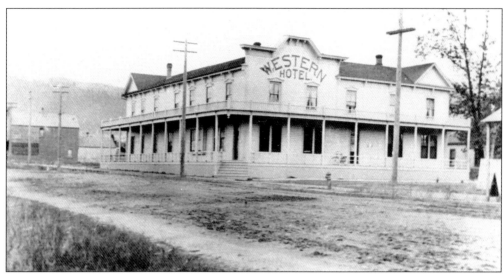

The Western Hotel on the northeast corner of Sixth and D Streets was built in 1890 and was the largest wooden building north of the railroad tracks. It stood until 1924. By that time, the bigger brick hotels took over the tourist trade. Before its removal, the Western Hotel was more of a boardinghouse (residential hotel) than a tourist hotel.

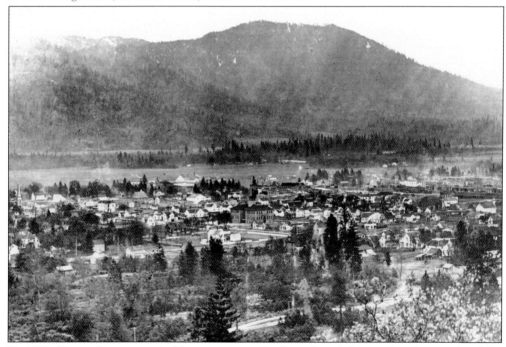

By 1892, Grants Pass was a sizable community. Looking from left to right, the steeple of the Methodist church, the courthouse, and other buildings can be seen along Sixth Street. To the right, the businesses along G Street stand in a row facing the railroad tracks. Across Sixth Street on G Street, a flagpole and fence can be seen around Railroad Park. The Rogue River can be seen in the background, and in the center is the Central School, opened in 1891. The old wooden school can be seen to the right. In the foreground is the road into town from the north, now known as Highland Avenue.

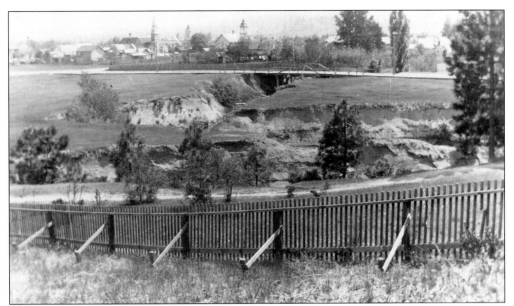

Located north of town and flowing on the west side of the city was the deep gully, which held the flow of Gilbert Creek. Gilbert Creek was named after Orson Gilbert, who had a donation land claim on the site as of April 1855. Thomas Croxton later purchased Orson Gilbert's claim. Gilbert Creek was a deep crevasse and filled with water during flood season. Eventually, bridges were built along all the westbound streets. Gilbert Creek and its parallel companion, Skunk Creek, were tamed, and large culverts were installed in 1939.

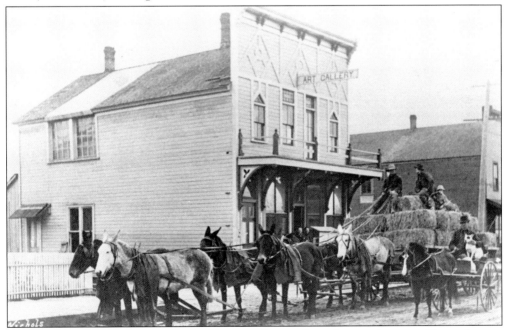

Between B and C Streets, a wooden building stood across from the courthouse and housed an art gallery upstairs and a chophouse (restaurant) downstairs. Note the glass skylight on the roof to allow sunlight into the art gallery. The six mules are pulling a load of hay. Maybe the workers stopped to eat en route. The one horse-and-carriage driver is taking his dog for an afternoon ride.

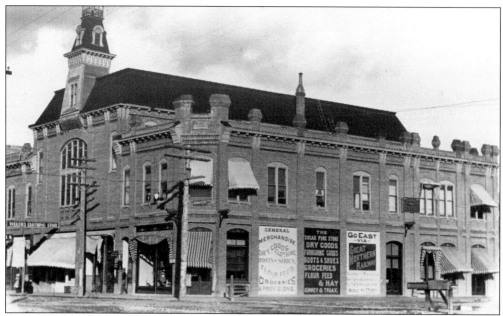

The opera house in 1895 stood on the corner of Sixth and F Streets. It had businesses on the ground floor and a large auditorium on the second floor, along with office space on either side of the auditorium. It was about five years old when this photograph was taken. The building was heated with wood, and each stove or fireplace was connected to a flue and chimney. Fourteen chimneys can be seen on the south side of the building in this photograph.

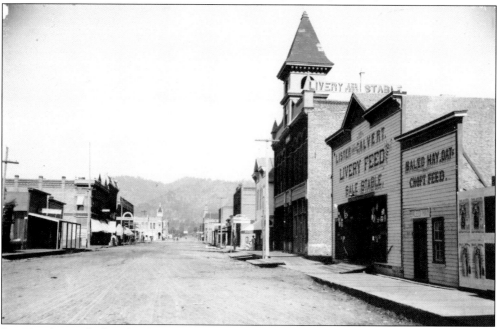

In 1894, the city hall and jail was moved to this large building on Sixth Street between H and I Streets. The fire department, city offices, and jail were located in the building with the cupola. The wooden International Order of Odd Fellows (IOOF) Building was to the north and was replaced with a brick lodge hall in 1897.

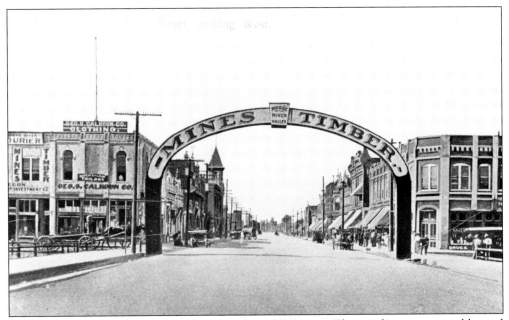

Two arches were located on Sixth Street at G and F Streets. The wording was moveable, and different phrases were put on the arches. The arches are seen in many photographs for about five years up until 1910, when the street was paved, and the arches were removed. This view is of the arch at G Street. The building on the corner to the left, the George Calhoun Clothing store, was the first brick building constructed in Grants Pass.

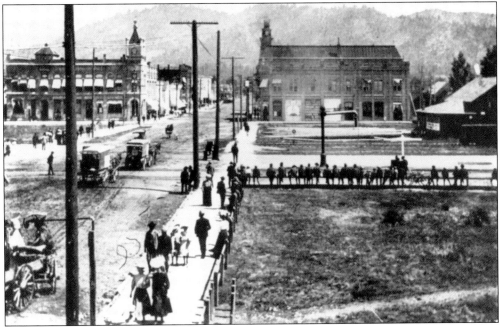

By 1895, Grants Pass was a thriving community with many two- and three-story buildings. The main street was no longer Front Street (now G Street) but had shifted to Sixth Street. Railroad Park was a gathering place in the center of town. It did not have picnic tables or benches, but the fence worked just fine as a place to sit and talk.

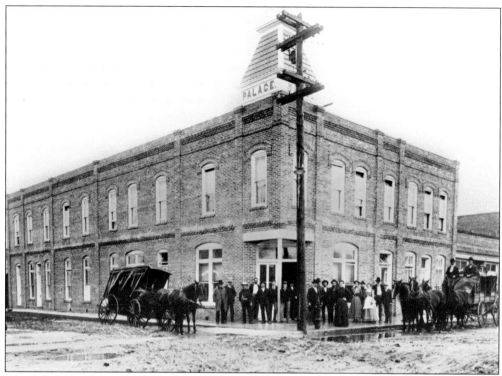

The Palace Hotel on the corner of Fifth and G Streets was a place to stay after leaving the train or waiting for a stagecoach or friends to continue the journey. Taken in 1901, this photograph shows the entire staff of the hotel and a couple of stagecoaches waiting to load passengers.

The Hotel Blackburn was on the corner of Sixth and G Streets. Behind it, across the alley, is the hardware store facing Sixth Street with the Blackburn house above. A wooden bridge connected the two Blackburns crossing over the alley. For a few years, one of the first movie theaters, the Bijou, was located on the ground floor next to the hardware store.

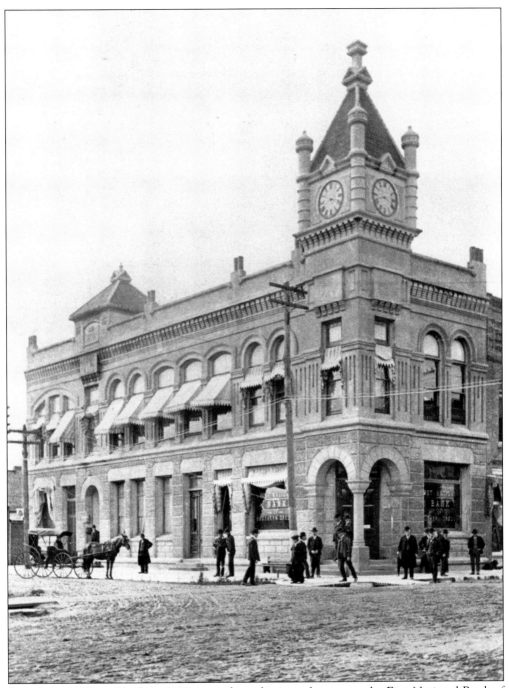

Founded in 1889 and built in 1890 across from the opera house was the First National Bank of Grants Pass, later called the First National Bank of Southern Oregon. The building was narrow on Sixth Street but extended west on F Street. Eventually, the Sixth Street facade was extended to cover part of the brick building to the north, and in 1926, the cupola was removed. The outside panels, which looked like large blocks of granite, were metal panels cast to look like stone.

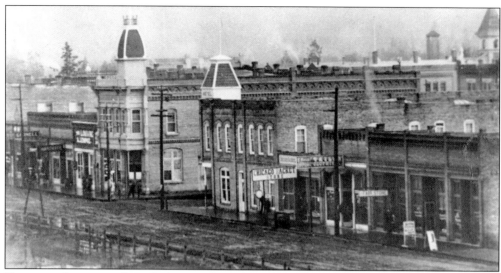

Two major fires swept through the wooden buildings along G Street in 1894 and 1902. Wooden buildings were destroyed, and brick building were gutted. The city passed an ordinance requiring new construction to be brick. This shows the refurbished and rebuilt G Street section at Fifth Street in 1903 between Fourth and Fifth Streets. Note the Chicago Racket Store in the center. A racket store was a forerunner of the variety store, which segued into the modern department store. The building in the center with the cupola was the Palace Hotel, built in 1894, and the other structure with the cupola is the Kienlen-Harbeck Building, erected in 1900.

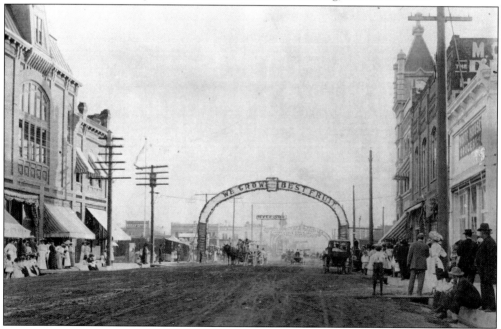

Looking south on Sixth Street from midway between E and F Streets, the hustle and bustle of the city can been seen. This was probably during a demonstration or a parade, but no notation is on the photograph. The crowds on the street indicate it was something of importance. Note the ladies sitting along the curb in front of the opera house. Both arches can be seen along the street in addition to various other signs strung overhead.

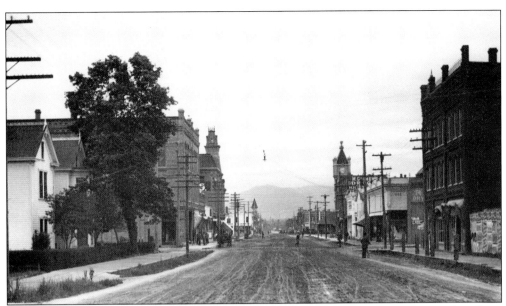

This photograph was taken from D Street and looks "down" the street. The two major identifying buildings, the ones most often photographed, are the two with the cupolas. The one on the left is the opera house, and the one on the right is the First National Bank. This was taken prior to 1909 because there is no brick Albert Building.

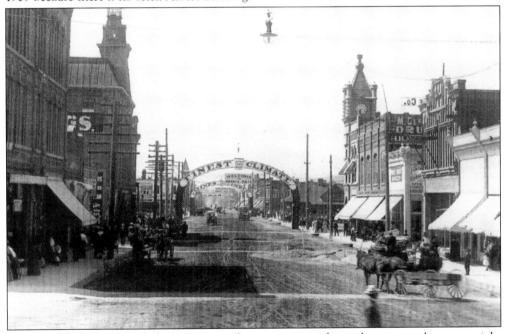

Probably taken in 1909 just before paving the street, a trench can be seen to the center right as the street was dug up. The Albert Building on the right and to the north of the alley was finished in 1909, and the front facade is unfinished in this photograph. Note the streetlight in the top center of the photograph. The police department had the ability to flash the lights from the office, if a policeman was needed. The light would flash, and the officer would go find out why he was summoned.

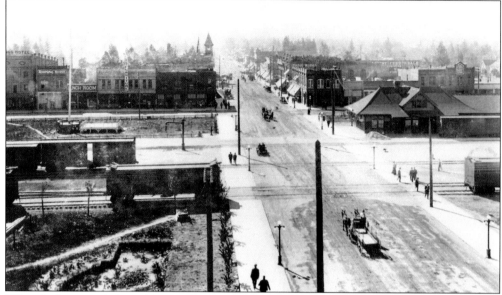

When looking south from the opera house cupola, no saloons can be seen. It is 1908, and Grants Pass has outlawed the sale of liquor. A fence-enclosed lawn has been planted in front of the railroad depot, a larger stage has been built next to the flagpole at Railroad Park, and even the woodshed for the locomotives has been moved elsewhere, but the water crane still stands by the corner of the park. A row of trees has been planted down Sixth Street in the foreground along with a decorative garden. An early automobile can be seen heading south across the tracks.

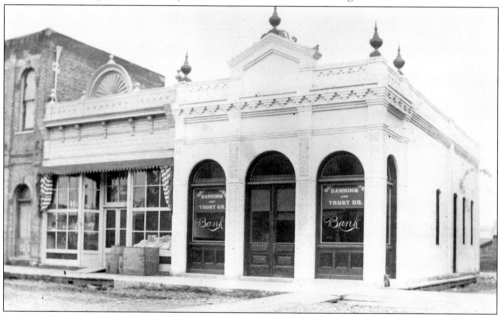

In 1901, Grants Pass Banking and Trust Company was on the east side of Sixth Street between G and H on the north side of the alley. It had an ornate front facade that disappeared with remodeling, but the roofline facade on the alley side can still be seen today. In 1902, the Josephine County Bank became the Grants Pass Banking and Trust at Sixth and H Streets. This site closed as a bank and became the Bank Cafe.

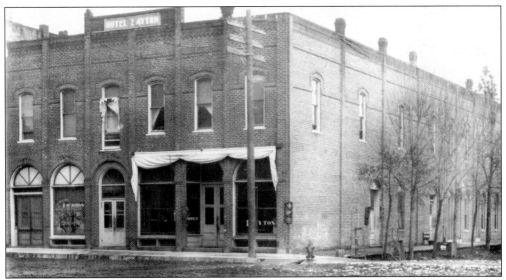

Jack Layton, a successful placer miner, had a one-story rooming house built on the northeast corner of Sixth and H Streets. It was a wooden building covered with galvanized sheet metal. It was removed in 1889 to construct the two-story Layton Hotel as a nicer "jumping off" place for prospective miners to stay before they went out to seek riches. It was also just a block from the railroad tracks, so was used by tourists as well. The lobby was at first on Sixth Street and then moved to H Street, and the front was rented out for two businesses, with a stairwell in between.

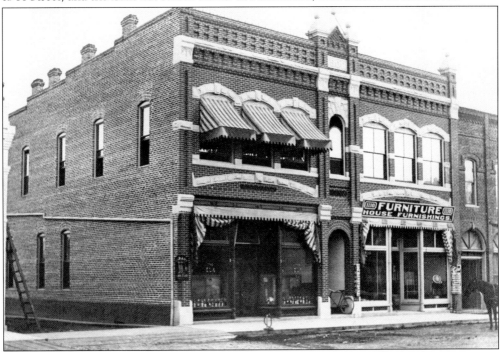

Built in 1900, with the year at the top center cornice, and located on the east side of Sixth Street along the alley between G and H Streets, this building had the entry for the upstairs on Sixth Street between the two storefronts. Across the alley was the Grants Pass Banking and Trust Company. The facade has been restored, and the building looks much like it did over 112 years ago.

21

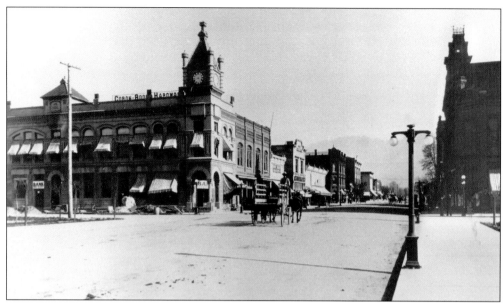

By 1911, Sixth Street was paved, and the arches had disappeared. Work on side streets was progressing as shown by the piles of gravel and construction material on F Street alongside the bank.

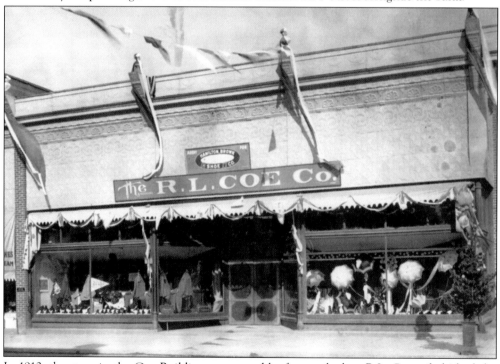

In 1912, the store in the Coe Building was gutted by fire, and when R.L. Coe refurbished the interior, he added a second story. This photograph, taken prior to 1912, shows the building on the corner of Sixth and D Streets as a single-story store. Many of the second stories on the downtown buildings were upstairs hotels, such as the Traveler, Layton, Southern, and Blackburn House. Other uses for the second stories were lawyers' and doctors' offices and private residences. The Coe Building housed offices.

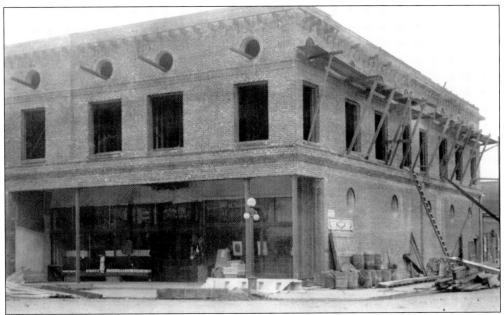

It is unusual to find photographic evidence of construction in the early 1900s. The rebuilding of the Coe Building after the 1912 fire that gutted the single-story building is shown in these three photographs. The metal plates, which were painted white and covered the original second-story facade, have been removed, probably destroyed by the fire, and a real second story has been constructed.

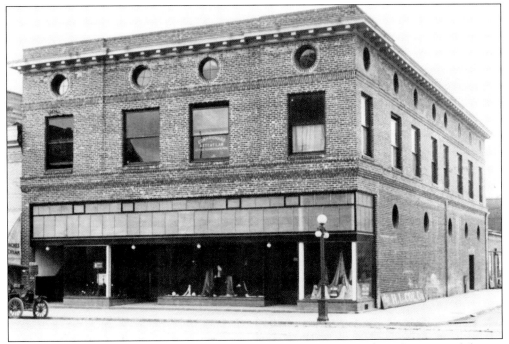

The completed Coe Building is finished with the fine touches of round windows around the top of the second story and a tin facade border above the windows. When refurbished, the structure was left with the natural redbrick and not painted as it was before the fire.

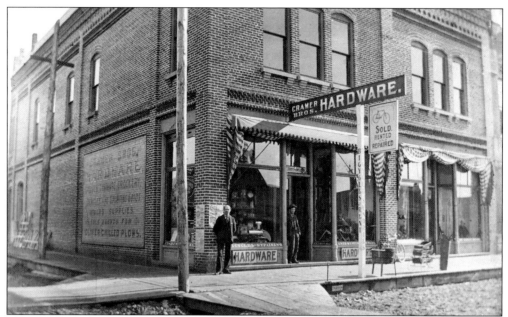

Cramer Brothers Hardware Store was located in the first-story portion of the IOOF Building. The International Order of Odd Fellows provided space to rent in the lower portion of their building, and the rental fees have helped them to provide for charitable endeavors in Grants Pass for well over 100 years.

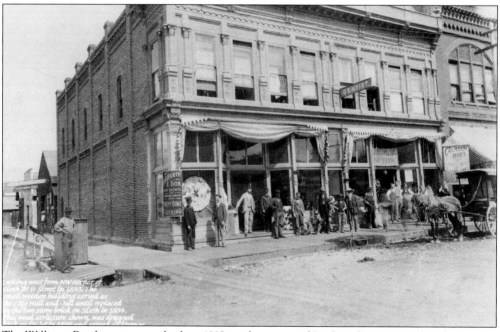

The Williams Brothers store was built in 1893 on the corner of Sixth and H Streets This photograph was taken when the building was new, and typical of the times, everybody in the vicinity came to pose for the photograph. The third building to the left behind the Williams Brothers was a little wooden shack, which served as the city hall and jail until the two-story brick city hall and jail was built on the east side of Sixth Street between H and I Streets in 1894.

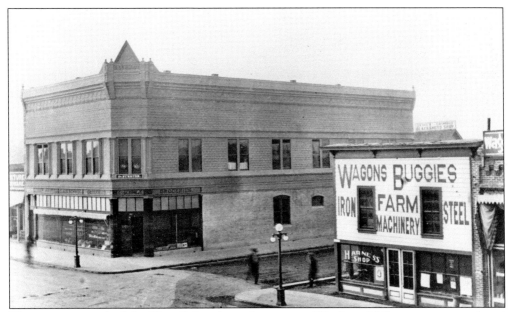

The grocery store built by Claus Schmidt on the corner of Sixth and I Streets was constructed around 1904. Claus's eldest daughter Anna Schmidt, born in 1888, quit school in the eighth grade to become the bookkeeper for the store. Claus Schmidt ran the store until his death, and then, son Herman and daughter Anna continued the business. After Herman died, Anna ran the store until retirement, and it was sold and torn down to build the new United States National Bank in the 1960s.

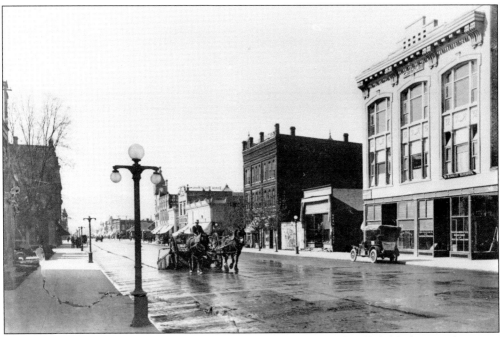

Sixth Street was paved with the macadam process in 1910. Commonly called "blacktop" today, it was called macadamizing at the time. The horse-drawn wagon is laying down the macadam, which was named for the inventor of the process. The Conklin Building is to the right of the photograph.

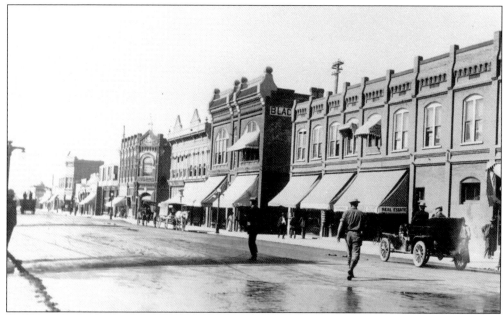

Buildings south of the railroad tracks are located on South Sixth Street, and those north of the railroad are on North Sixth Street. In the 1950s, addresses were adjusted because prior to that time addresses were numbered from G Street and not the tracks when going north and south. The side streets were numbered starting at Second Street, moving east. This shows South Sixth Street between G and H Streets on the west side in 1915.

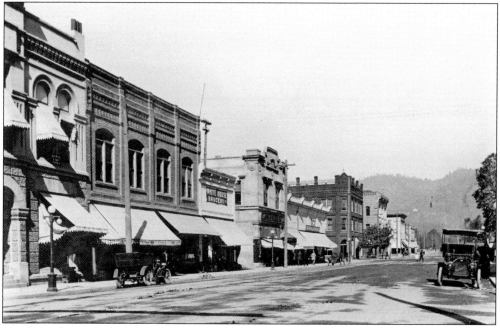

North Sixth Street is shown between 1909 and 1912. Dating photographs can be interesting when nobody bothered to write anything about the photograph. This can be dated because the Albert Building (center) was completed in 1909 and the Coe Building to the right is still a single story.

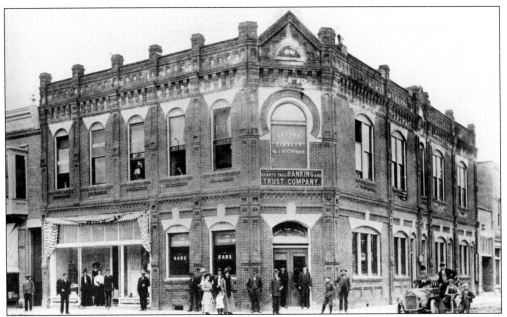

The Tuff's Building was built in 1901 on the corner of Sixth and H Streets. This photograph, taken in 1909, is of the Grants Pass Banking and Trust and the first Golden Rule store. Second from the left is Frank Vannice of the Golden Rule store.

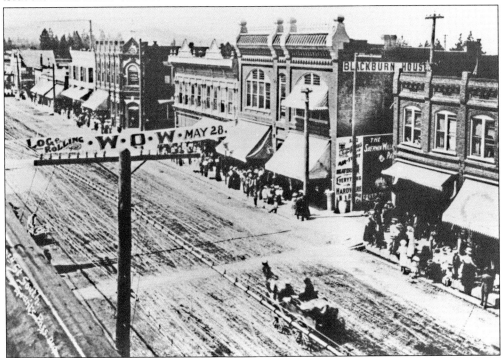

The WOW banner was for the logrolling competition for the Woodmen of the World, which was formed in 1890 in Nebraska. The date May 28 fell on Saturday only in 1904 and 1910, and the buildings shown were built before 1901. An educated guess at the year the photograph was taken is either 1904 or 1910.

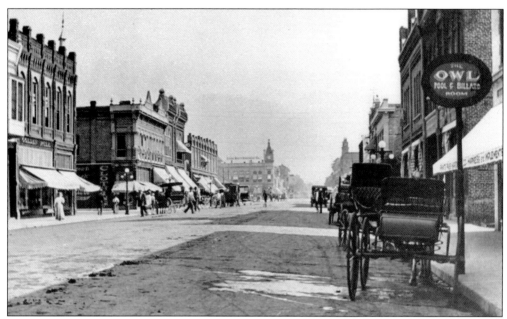

The Owl Pool and Billiard room was on Sixth Street in the Calvert Paddock Building, which was built around 1910. Up the street from the pool hall were the city hall and the IOOF lodge. Across H Street was the Layton Hotel. False facades around rooflines often made buildings look taller. As remodeling proceeded over the century, the buildings looked shorter when the false facades, parapets, and cupolas were removed.

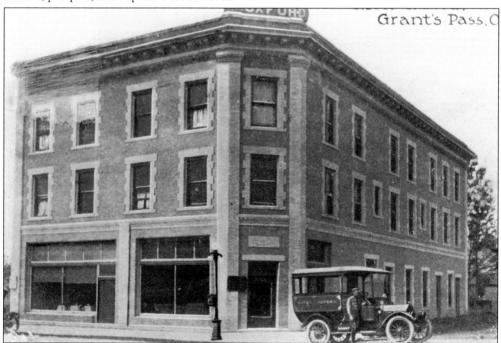

The Oxford Hotel was redbrick outlined in white brick when it was built. When it was remodeled in 1927 with an addition to the south and west sides, the name was changed to the Hotel Del Rogue.

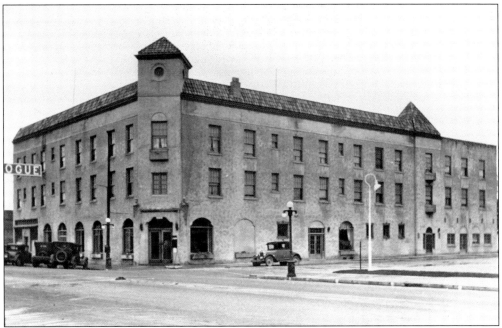

Newly refurbished, the Hotel Del Rogue was styled to resemble architecture in California. The Roaring Twenties was when many California trends arrived in Southern Oregon. The hotel was made twice as wide on Sixth Street, and its depth down K Street was extended by one-third. As the other refurbished hotel, the Redwoods, the Hotel Del Rogue was painted "rose wood" pink.

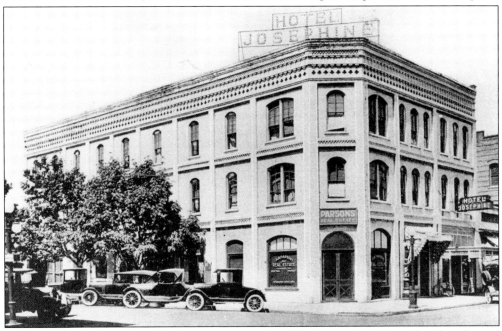

Built in 1893, the Josephine Hotel was just a couple of blocks north of the railroad tracks and convenient for the railroad traveler. Originally heated by wood-burning stoves, it was the first Grants Pass building to be equipped with gas for cooking and heating. It stood at the corner of Sixth and E Streets. This portion of the hotel burned down on April 13, 1975.

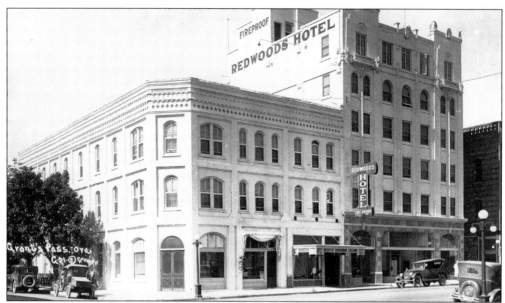

A six-story "tower" was built next to the old Josephine Hotel in 1926, and with the opening of the Redwood Highway from San Francisco to Grants Pass, the newly built and remodeled hotel was renamed the Redwoods Hotel. The new addition was considered fireproof. For most of its existence, it was painted pink and sometimes off white. After the old portion burned in 1975, that part of the gutted building was demolished.

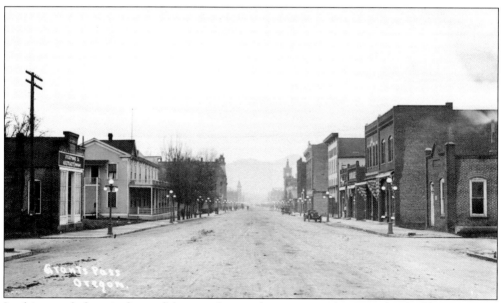

Looking south from in front of the courthouse, the transition from wooden buildings to more sturdy and fireproof brick buildings begins to take place. In the distance, the three cupolas that topped the bank, opera house, and city hall can be seen but were soon to disappear, as the "old-fashioned" look of Grants Pass started to modernize.

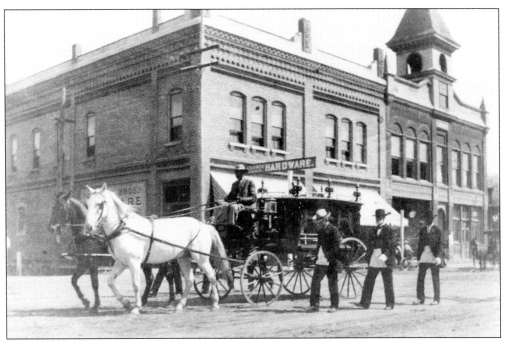

Just after the new IOOF Building was finished in 1897, this photograph shows members escorting a deceased member past the building to his final resting place. The IOOF still owns the building and rents the ground level to a business. Their cemetery is still in use.

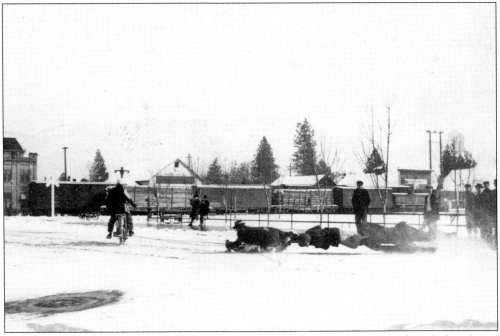

On January 1, 1916, it snowed in Grants Pass, and these "boys" rigged up two sleds and a long board so three of them could slide across Sixth Street at G Street. Railroad cars are in the background, and to the far left is the opera house. Pedestrians watched as they started their journey, and evidently, a photographer was called to record the event.

As they slid across Sixth Street, the make-do vehicle fell apart, landing all three in the snow on G Street in front of the railroad freight depot. The snowfall was an interesting topic for the photograph, but just as important is the lineup of railroad cars with the depot showing the width of the land taken up by the railroad in the center of Grants Pass. The only thing written on the photographs is the date.

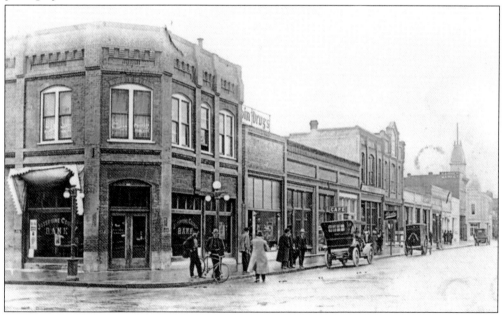

Across from where the sled fell apart was the Blackburn Hotel, later converted into the office of the Josephine County Bank with office space upstairs. The bank was founded by Frank S. Bramwell of the Sugar Beet Company, which was short lived in Grants Pass. Dr. Flanagan owned the building, and his office was located upstairs. In 1930, it was demolished and replaced by a concrete building, which was not quite completed when it was sold to the United States National Bank of Portland.

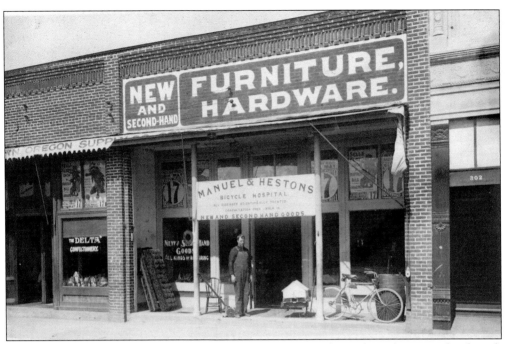

The Manuel and Heston Furniture and Hardware Store was located on the west side of south Sixth Street in the 300 block. The building is the Rausch Building, and this photograph from the Heston family collection was taken about 1917. The sign reads, "Bicycle Hospital. All diseases scientifically treated. Consultation Free. Walk in."

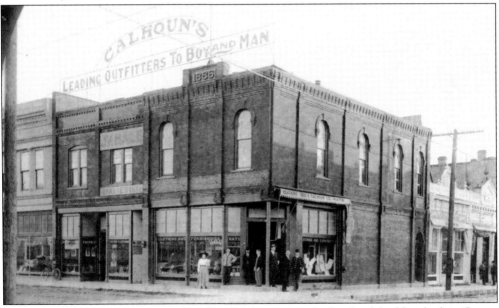

Standing on the southeast corner of Sixth and G Streets was the first brick building built in Grants Pass in 1886. Built by J.W. Howard, the building housed many businesses and stood until about 1947, when it was demolished to build the Wing Building. The front and side facades changed over the years, and when they were finally removed, there was white stucco with oval windows to suit the Club Café, which was the final tenant (see page 43).

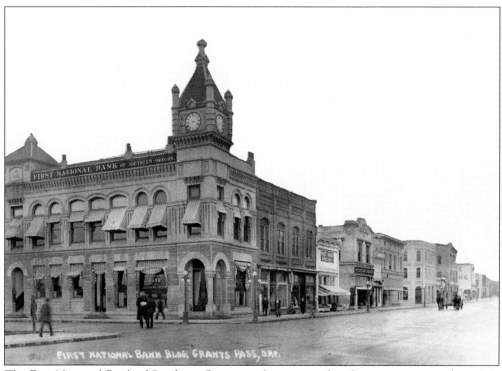

The First National Bank of Southern Oregon is shown just after the street was paved in 1910. The clock was for show and never worked because there was no clock mechanism installed. This, as most early buildings, was heated by wood and had several chimneys pointing skyward from the roof.

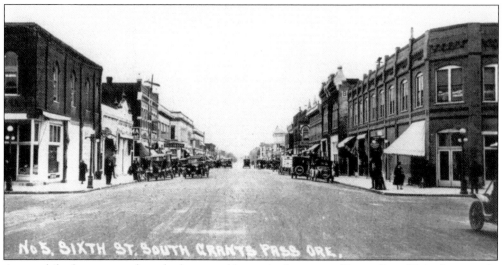

Automobiles began to replace the horse and buggy in downtown Grants Pass. This photograph, taken in the late 1920s, shows how well the town was laid out with wide streets that handled the horseless carriage as well as it did the surrey with the fringe on top. Many cities had narrow streets in the beginning, and urban renewal caused many of the old buildings to be destroyed to widen the roads. Grants Pass never had to contend with that, and many of the buildings in the center of town are well over 100 years old and still functioning.

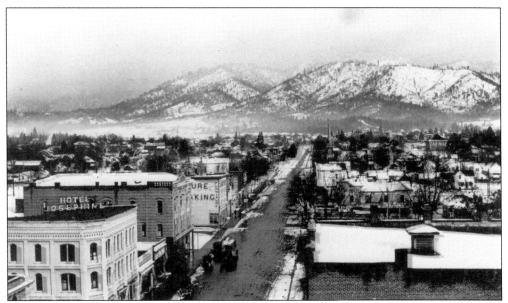

Looking north, this c. 1908 photograph shows most of what is needed for a well-functioning town. Eastside School is to the right, and Central School is to the left in the background. The courthouse can be seen on the left side across from the steeple of the Methodist church. The wooden Western Hotel is to the right, and the Hotel Josephine is to the left. With its sign partially covered by the Conklin Building in the foreground is a wooden building with "Furniture" and "Undertaking" painted on the south wall.

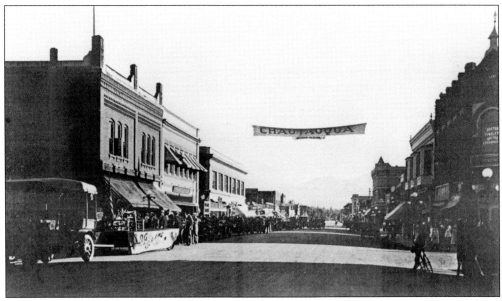

At the corner of Sixth and H Streets, people gather to see a short caravan of automobiles advertising a logrolling contest. It was probably sponsored by the Woodmen of the World since a giant W can be seen on the banner. Overhead flies a banner advertising the Chautauqua program coming in July.

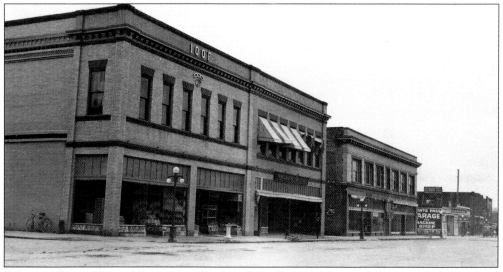

Taken in about 1920 and donated to the Josephine County Historical Society by the estate of Charles Vannice, this photograph shows the block between H and I Streets on South Sixth Street. The buildings on this block still exist today, and two have been restored to look as they did in the beginning. In the center is the Golden Rule store. Obviously, this photograph was taken early in the morning before the streets filled with cars and people.

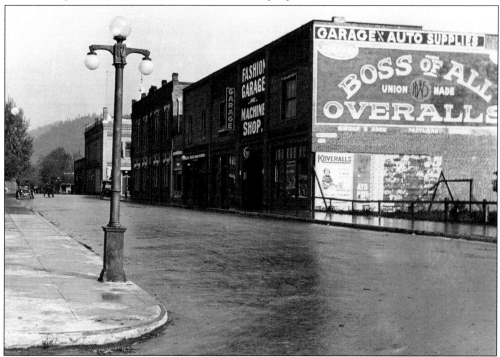

The corner of Fifth and H Streets, with the new macadam surface, shows the east side as being still residential beyond the IOOF Building. The Tuff's Building, along with the IOOF, still has chimneys since many businesses heated with wood. The Tuff's Building would expand west, and the Fashion Garage would become the new Ford Agency. The construction of Winetrout Ford was done by Gus Lium, who also built the Oregon Caves Chateau.

After the initial building of Grants Pass, Front Street facing the railroad tracks became G Street. It thrived for a few years, and then the business district shifted to Sixth Street. In the interim, many of the buildings housed saloons, and "nice" folks did not frequent the area. It escaped the renewal frenzy, and today, most of the old buildings still stand, refurbished to their days of glory, and house businesses in the growing town.

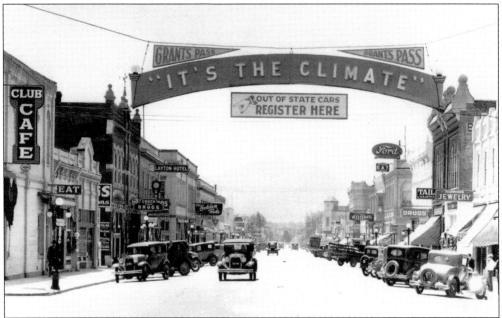

Sixth Street was Highway 99, and all people traveling north or south on the highway had to drive though the center of town. In the early 1920s, a local businessman suggested the building of a sign across the street similar to the ones that stood prior to 1910. It was a ploy to get people to stop and spend time and money in Grants Pass. It worked. The arrow pointed toward the Chamber of Commerce Office, and many a traveler stopped to inquire about local activities.

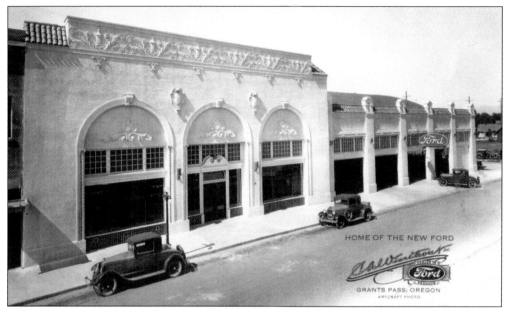

C.A. Winetrout Ford opened in the newly remodeled Fashion Garage and a newly built repair section at Fifth and H Streets. In 1923, Winetrout was on the corner of Sixth and K Streets and at this new location on Southwest H Street by 1932. The building later became the Montgomery Ward Store when Winetrout moved to Sixth and I Streets.

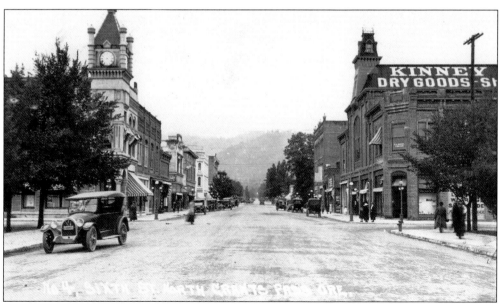

Around 1920, before the cupolas were removed and the tower of the Redwoods Hotel was built, this was the view looking north up Sixth Street from the railroad tracks. By 1927, the street would have a different look.

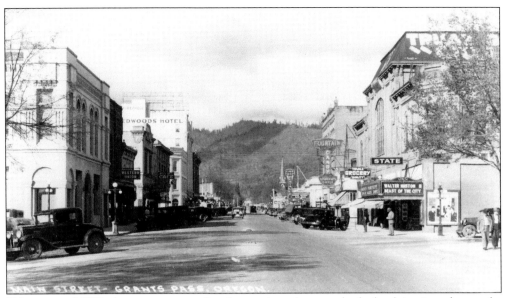

Taken around 1927, about seven years after the previous photograph, the bank is minus the cupola, the Redwood Tower has been added to the old Josephine Hotel, with the name changed to the Redwoods Hotel, and the opera house has become the State Movie Theatre.

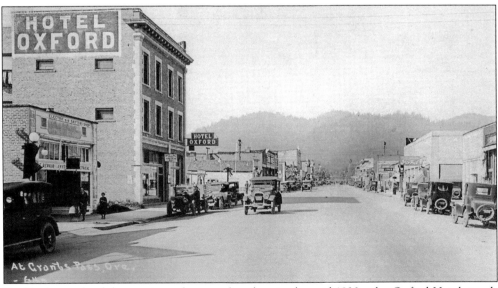

Six blocks south of the previous photograph, taken in the mid-1920s, the Oxford Hotel stands on the corner of Sixth and K Streets awaiting the building project to make it into the Hotel Del Rogue. As the Hotel Del Rogue it would have a red tiled roof facade, giving it the look of the Mexican motifs used in California.

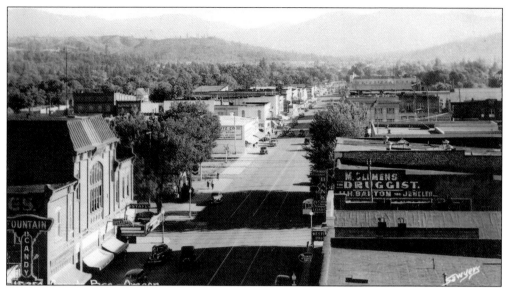

By the 1940s, Grants Pass had a new post office, seen to the right behind the trees, and a new J.C. Penney Store on the corner of Sixth and G Streets, located next to the Sprouse Reitz store just south of the railroad tracks. Note that the "It's the Climate" sign is gone. This photograph was taken from the Redwoods Hotel.

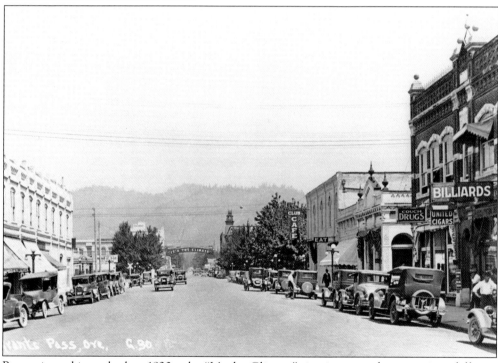

Regressing a bit to the late 1920s, the "It's the Climate" sign is across the street in a different location. Since the sign was attached to the Blackburn Hotel building and the Club Café, it moved prior to the demolition of the old Blackburn Hotel, located on the left at the corner of Sixth and G Streets. The old hotel was torn down for the construction of a new building, which would be occupied by the United States National Bank in 1930.

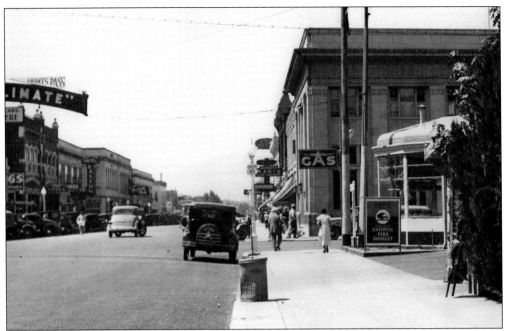

The main street of Grants Pass, Sixth Street was Highway 99, the primary highway until Interstate 5 opened in the 1960s. The Highway 99 road marker can be seen on the lamppost, and across the sidewalk is a sign giving the mileage to cities north and south. This photograph was taken in the mid-1930s. The United States National Bank was torn down around 1962. The taxi in the center has "Flying A" written on the spare-tire cover. An Associated Oil Company's Flying A service station was on the corner.

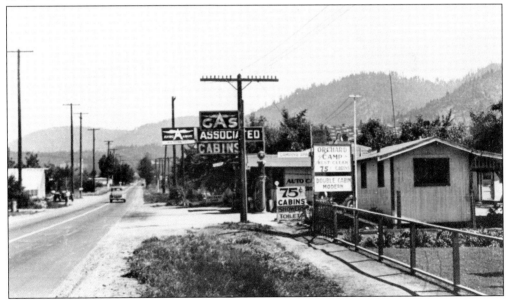

North of the business district of Grants Pass, Highway 99 was not called Sixth Street but was Orchard Avenue. In 1935, motels were a new concept and were called auto courts and had areas to camp in case the patron did not want to stay in a cabin. The Orchard Camp offered "clean cabins" for 75¢ a night, and a toilet was included in the cabin.

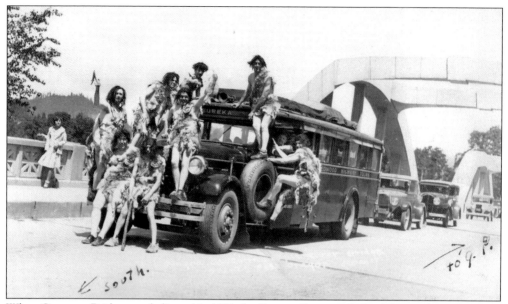

When Caveman Bridge was dedicated in 1931, the Oregon Cavemen helped during the ceremonies. The Oregon Cavemen were formed and incorporated under the laws of the state of Oregon in 1922 as a booster organization to promote Grants Pass as the gateway to the Oregon Caves and the Redwood Empire. Many businesses in Grants Pass use the Caveman name, and the Caveman is the team name for Grants Pass High School.

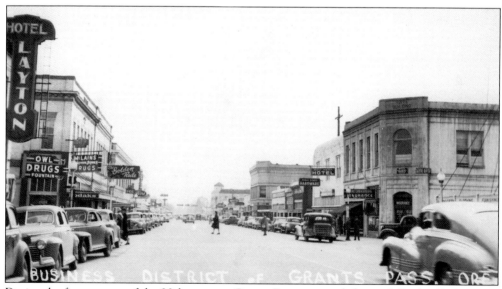

During the first quarter of the 20th century, Grants Pass grew and changed. By the 1940s, many of the ornate old buildings were covered with stucco, and the cornices and fancy facades became plain and modern. The corner of Sixth and H Streets shows the 1901 Tuff's Building looking rather plain and commonplace and not at all ornate.

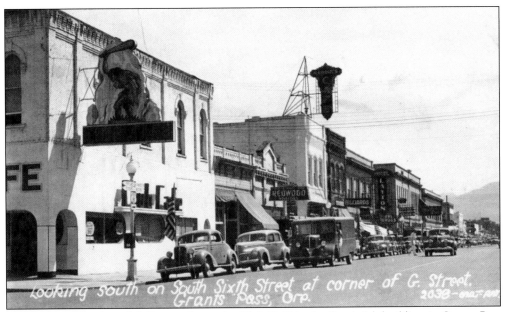

The corner of Sixth and G Streets shows the Club Café in the first brick building in Grants Pass when it was about 50 years old. This view of the east side of Sixth Street shows all the existing buildings that remain on Sixth with the exception of the Club Café and the building behind it, which were demolished around 1947 to build the Wing Building.

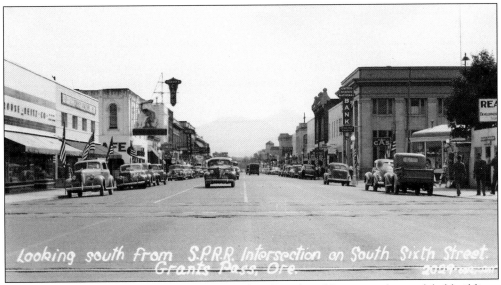

Looking south from the Southern Pacific Railroad tracks, old, new, and remodeled buildings can be seen along Sixth Street. On the left (east) side are Sprouse Reitz, J.C. Penney, Club Café, Redwood Novelties, Hadley's, Nandies, a billiards parlor, Layton Hotel, Owl Drugstore, Golden Rule, and the Winetrout Ford dealership. On the right are the Flying A service station and United States National Bank, and the four taller buildings are the Sherer-Judson Building, Tuff's Building, Schmidt Grocery, and Hotel Del Rogue.

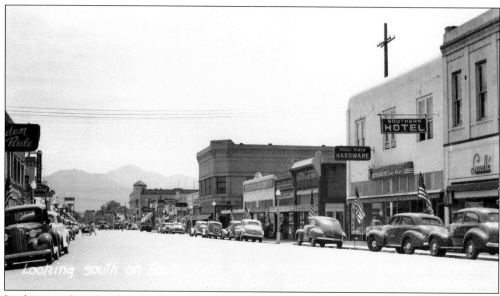

Looking south on Sixth Street from H Street, this shows a view of the west side where the Schmidt Grocery and the Hotel Del Rogue, farther down the street, stand above the rest.

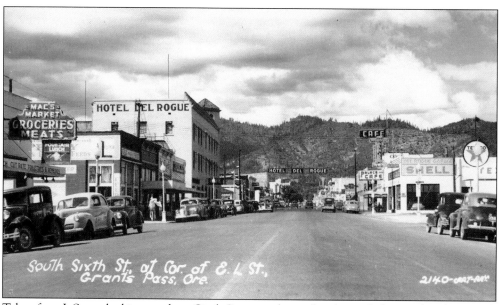

Taken from L Street looking north on Sixth Street at almost the identical place as the photograph on page 39, this shows the enlarged hotel, no longer the Oxford, but renamed the Hotel Del Rogue. To the left is Mac's Market, which later became Kampher's and then Byrd's Market.

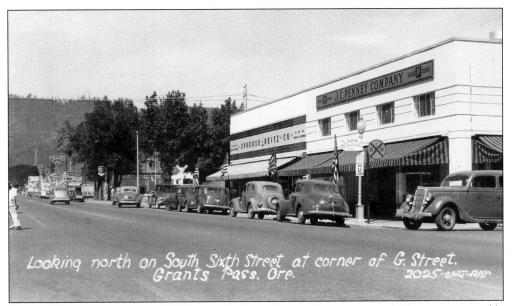

Built in 1941, Sprouse Reitz and J.C. Penney lie alongside the railroad tracks, which are not noticeable except for the railroad crossing sign aligned with the flags. A Standard Oil service station is on the corner of Sixth and F Streets, and the State Theatre is hidden behind the trees.

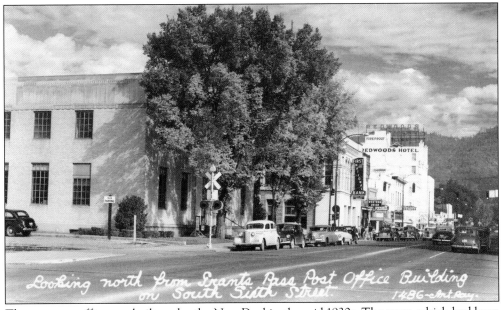

The new post office was built under the New Deal in the mid-1930s. The trees, which had been planted around 1908, survived the construction.

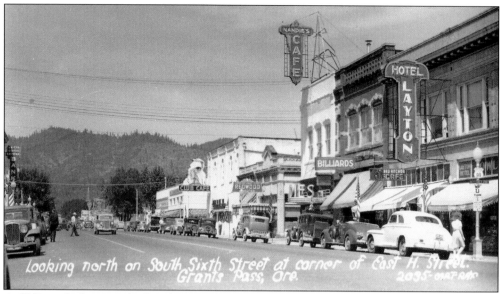

At H Street looking north, this photograph was taken between 1941 and 1947 and shows the same buildings with different businesses. Many businesses were long lived but moved from building to building throughout the downtown area.

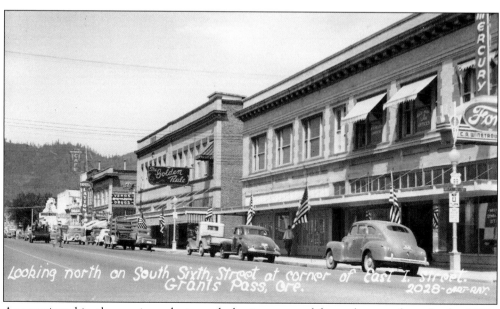

As mentioned in the previous photograph, business moved from place to place. In the 1920s, Winetrout Ford was located on the east side of Sixth Street between J and K Streets. It then moved to H Street, which once housed the Fashion Garage. The building became Montgomery Ward after they moved to the corner of Sixth and I Streets, shown here.

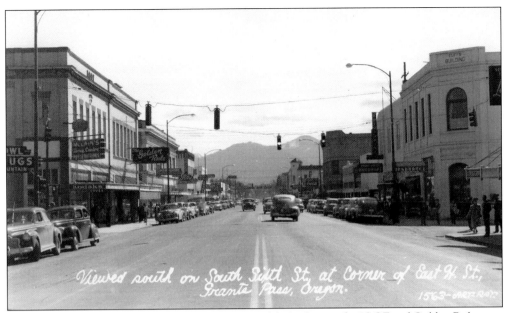

The 1901 Tuff's Building to the right has been remodeled, whereas the IOOF and Golden Rule store on the opposite side remain much the way they were 40 years before. The following photograph shows the Tuff's Building again remodeled with the name removed and a view of the west side of Sixth Street from H to K Streets.

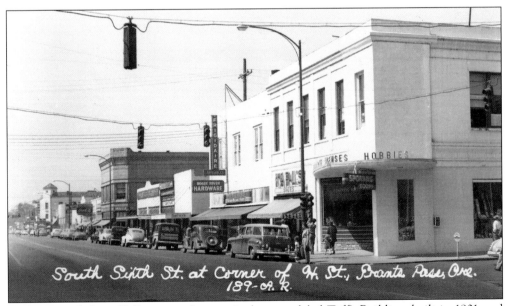

Looking south from H Street on the west is the remodeled Tuff's Building, built in 1901 and remodeled several times over the years. This photograph shows Grants Pass Sporting Goods, Karl's Shoes, Rogue River Hardware, Hadley's dress shop, Ted Paulus Hardware, McGregor's, and then, across the street on Sixth and I Streets, the Schmidt Grocery store. Down Sixth Street is the Hotel Del Rogue with the Californian-style tile roof and a sign strung across the street.

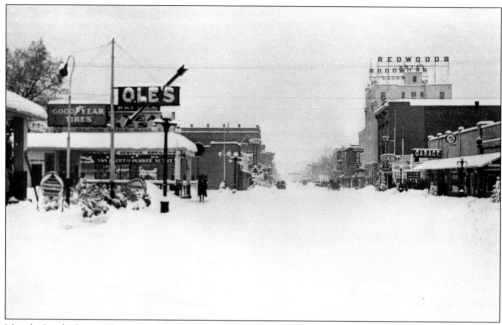

North Sixth Street shows Ole's Hamburger Stand, which was located north of D Street on the east side of Sixth Street next to a service station owned by the same family. It existed for over a quarter century from the 1920s to 1950s.

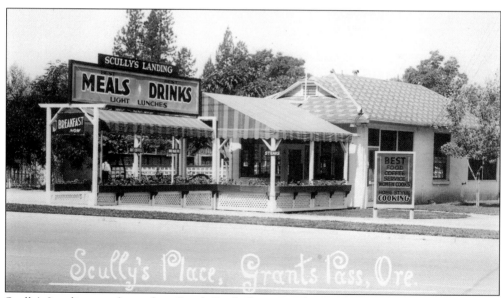

Scully's Landing was located on South Sixth Street on the west side of the street next to the bridge in the 1920s. The Bridge Motel was built along the river to the left of the restaurant. It later was known as the Green Parrot Restaurant. After the restaurant closed, it became an Associated Oil service station.

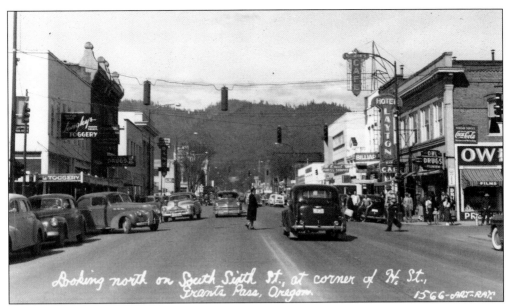

Taken about 1948, this photograph is looking north at H Street. The Owl Drugstore can be seen, with the King Café next door. Past that are the billiard parlor, Excel Dress Shoppe, and Wing Building, and then J.C. Penney and Sprouse Reitz stores. Beyond the tracks is the old opera house. On the west side, starting from H street, there are Langley's Toggery, Commercial Finance, National Drug, and United States National Bank, and across G Street is the Flying A service station with the post office in the background.

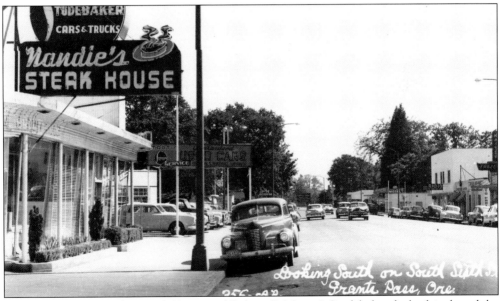

In the late 1940s, Nandies Steak House and Robert C. Martin's Studebaker dealership shared the same building. This photograph was taken from M Street, looking toward Caveman Bridge. Across the street, just out of sight, was the Piggly Wiggly grocery store. The Kaiser-Frazer automobile dealership was on the west side, across from H&H Motors. Just before veering left across Caveman Bridge, the Redwood Empire sign can be seen.

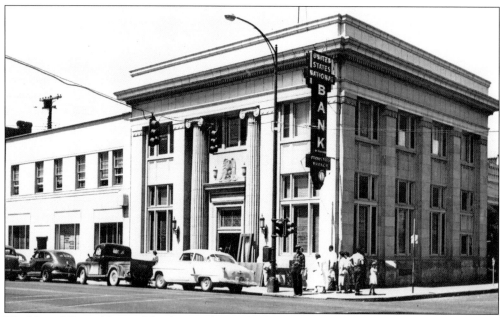

The United States National Bank moved into this building on March 15, 1930. Inside was a large room with teller cubicles on the north and west sides. The back portion (west side) was a giant vault with the opening in the center, located behind the teller cubicles. On the south side were desks for the bank officials. The president had a glass-enclosed cubicle at the front window, seen at the left of the doorway in this photograph. All the woodwork and cubicles were dark wood.

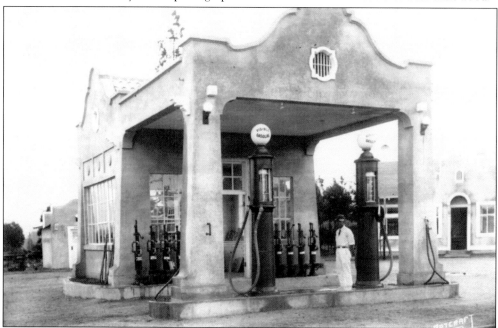

After crossing the Caveman Bridge heading south, the road split into three highways: Highway 99 (Pacific Highway) went east, Highway 238 (Williams Highway) went south, and Highway 199 (Redwood Highway) went west. In the mid-1920s, this service station was located at the intersection of the highways along with an information center for travelers.

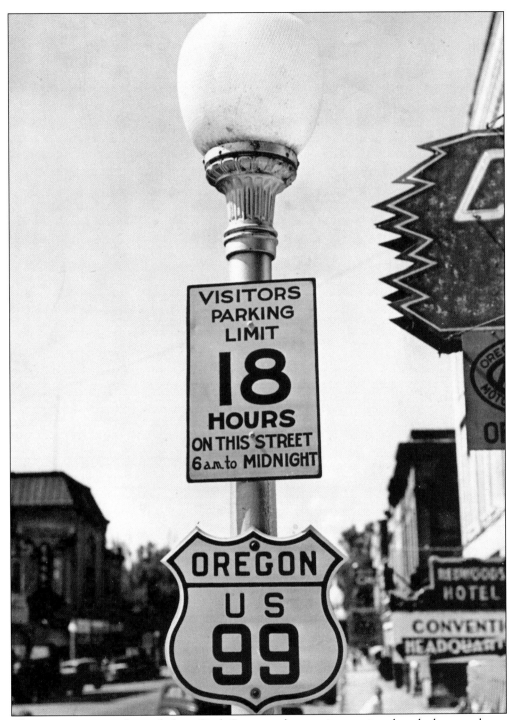

These signposts were located along Sixth Street so that tourists passing though the town knew they were still on Highway 99. This one was located in front of the Redwoods Hotel.

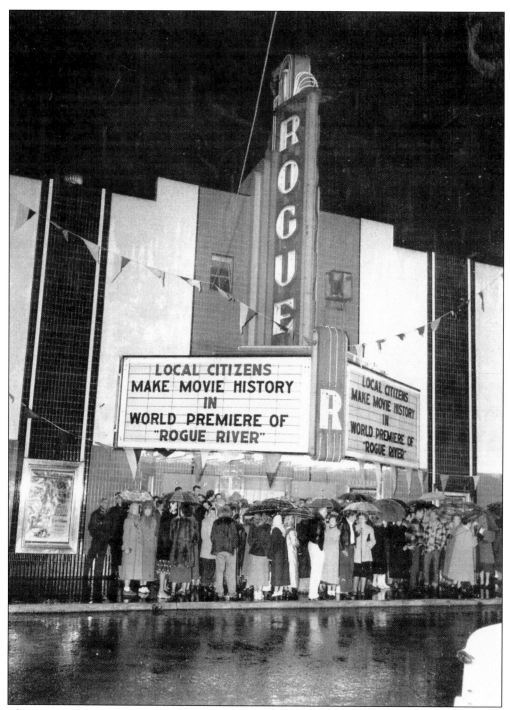

The Rogue Theatre on the corner of Seventh and H Streets opened about 1938 with ushers in blue satin uniforms. There were several other movie theaters in Grants Pass over the years, but when new, the Rogue was the showplace theater. It was a bit smaller than the Rivoli and the State. The Rivoli was one block north of the State Theatre on Sixth Street. The State Theatre was in the opera house building.

Two

Schools and Churches

As soon as Grants Pass got its name in 1864, a school was built. It was a log cabin and served not only as a school but also as a meeting hall and a church on Sundays. It was located near what is now Tenth and Savage Streets.

As church congregations grew, and the little log cabin school could not hold all the worshipers, individual churches began to be built. Many simply built their own little lean-to or cabin, or met in homes until funds and sites could be obtained. At one time, there were over 100 schools in Josephine County, each one serving the nearby neighborhood. Grants Pass was not very populated, and students attended the one-room schoolhouses in neighboring areas.

In 1884, when Grants Pass was about to be incorporated and just a few months after the arrival of the railroad, a group of businessmen purchased a large building that was located in Jerome Prairie. The building was dismantled, moved to Grants Pass, and rebuilt on the block between Third and Fourth Streets and C and B Streets. By 1886, a wing was added to the wooden school building along with a bell tower and a newly purchased school bell. In 1891, a brick building, erected on the same site, replaced the wooden schoolhouse. Initially known as Central School, it served all grades with the Grants Pass Academy, later called Grants Pass High School, occupying the top floor. An extra elementary school was built at the end of Fourth Street at Bridge Street but was soon full, and extra classes were held in city hall. Two brick elementary schools, Eastside and Riverside, were built. In 1911, a new Grants Pass High School was built on the current site of GPHS. Central School continued housing the elementary classes and was at different times known as Washington Junior High and Washington Elementary School. It was torn down in the 1940s.

At the same time, churches began to build permanent buildings. The townsite grid system created blocks and streets, and the town began to grow not just in the downtown area but also in residential areas surrounding the city center. Most of the first church buildings were located on a corner and had a steeple and/or a bell tower. Tolling of the bells each Sunday morning to commence church services became commonplace.

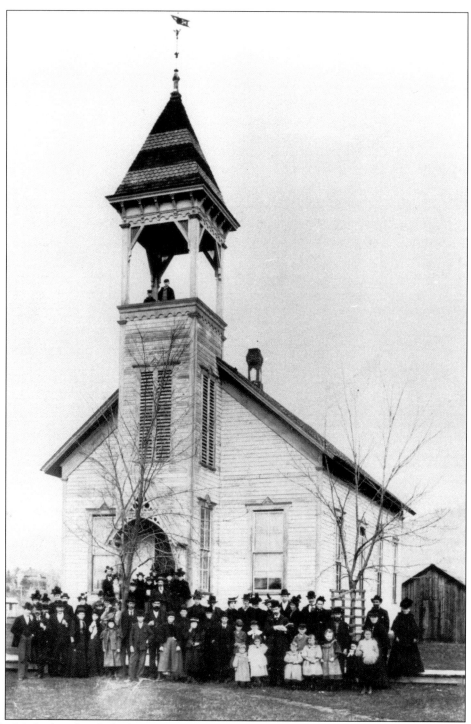

The Methodist church, built in 1886, was quickly outgrown and was moved from the site by the Church of the Brethren when the Methodists built a new building in 1890. It was moved to E Street between Second and Third Streets. The Methodists established their congregation in Grants Pass in 1857. They celebrated the Sesquicentennial Anniversary in 2007.

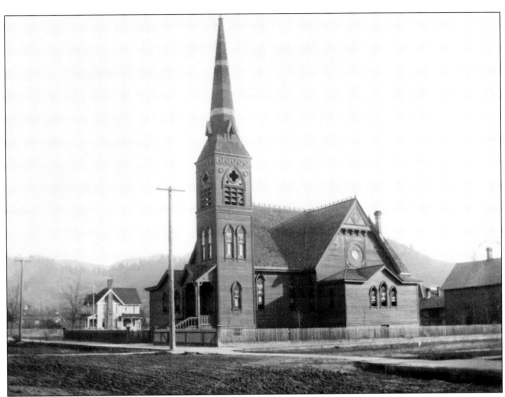

The second and current Methodist church, built in 1890, stands at the corner of Sixth and B Streets. This has been a landmark building for over 100 years. It has been refurbished and repaired over the years and still stands tall despite a fire and being struck by lightning. It is a Gothic-style design, and the interior floor plan is in the shape of a cross.

The first Baptist church was built and dedicated in February 1890. It was destroyed by fire in 1902 and soon replaced. The replacement burned down in 1936. The courthouse is in the background to the left, with the Methodist church to the right.

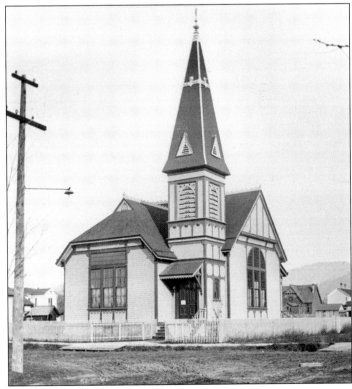

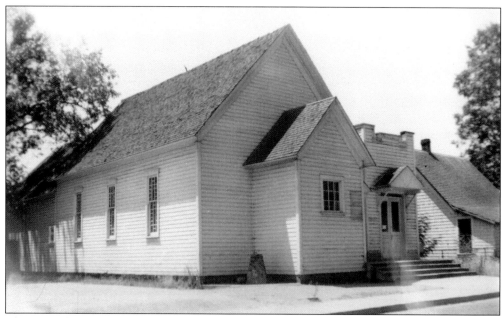

The Seventh-Day Adventists built their church in 1893 on the corner of Eighth and E Streets at a cost of $800. The Adventists have had a presence in Grants Pass from the first meetings in July 1889. On May 4, 1890, they were officially designated as a church but without a permanent meeting place. They met in various homes until they raised the funds to build a church building. The new building was dedicated on September 27, 1894, the seventh church built in Grants Pass.

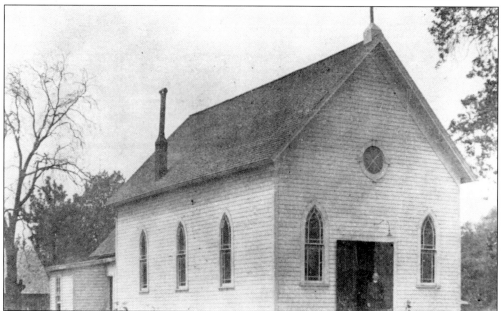

The first Catholic church was St. Anne's and was built in 1896 and blessed and dedicated on October 11, 1896. It was named after Saint Anne de Beaupre in Canada because the majority of Oregon's priests came from that area. The first resident pastor was Fr. M.J. Hickey who came to Grants Pass in 1899. Circuit-riding priests tended the congregation before a resident pastor was assigned. In 1904, a rectory was built next to the church.

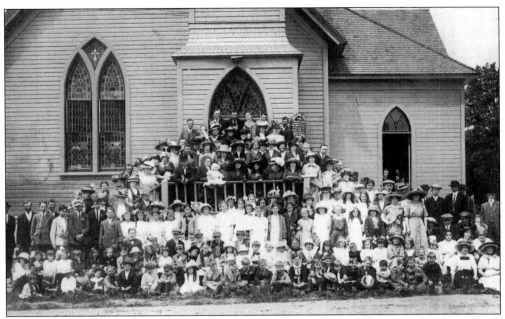

The First Christian Church members posed for a photograph in 1912. The First Christian Church was organized the second Sunday in January 1888. The first church was erected at the current location on the corner of Fourth and H Streets. In 1892, it was incorporated as the Church of Christ at Grants Pass, Oregon. In 1925, it officially changed its name to the First Christian Church, but it took over two decades before the new name was used exclusively.

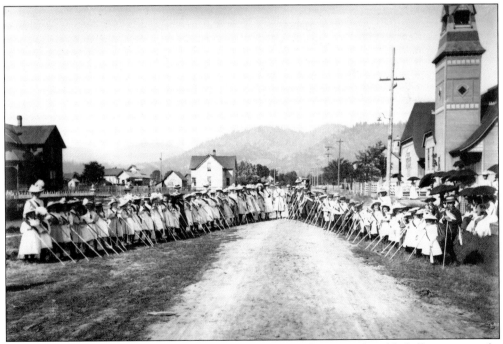

Looking east at the corner of Third and E Streets, the Presbyterian church's drill team poses for a c. 1888 group photograph. Just to the right of the power pole, Central School's bell tower can be seen. Central School was on Fourth Street between B and C Streets.

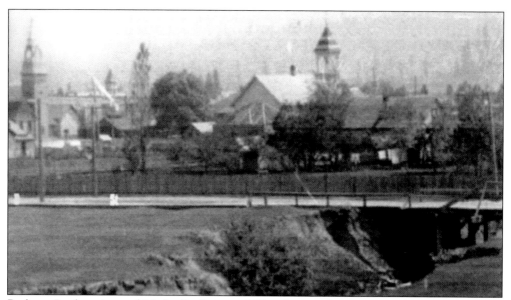

Bethany Presbyterian and Methodist Episcopal Churches are shown on Northwest E Street near Third Street. The bell tower of Central School can be seen in the background between the two bell towers. Looking northeast, this photograph was taken from along Gilbert Creek.

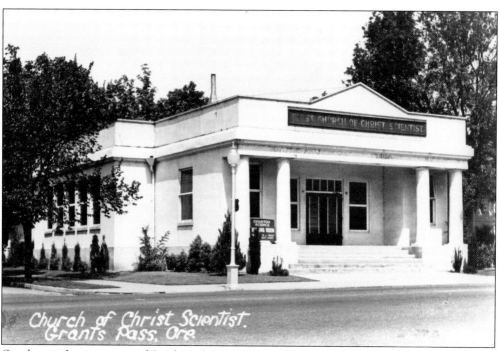

On the southwest corner of Sixth and B Streets, the First Church of Christ Scientist served both as a church and the Christian Science reading room in the 1950s. When a new church was built, this building became part of the courthouse complex and is called the Anne G. Basker Auditorium.

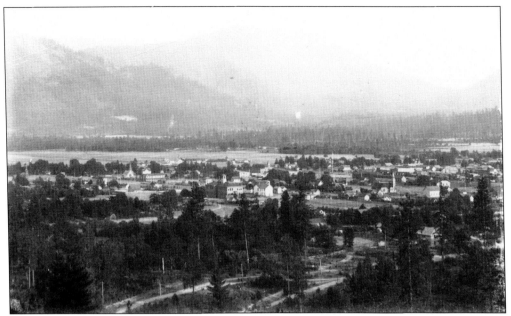

Taken from above Highland Avenue, which is seen in the foreground, the center of this photograph shows the newly built brick Central School with the original wooden school building to the right before it was dragged across C Street and eventually dismantled. The wood was used again to build houses, one of which still stands on C Street. Starting at the left edge, one can see the city as it was in 1892.

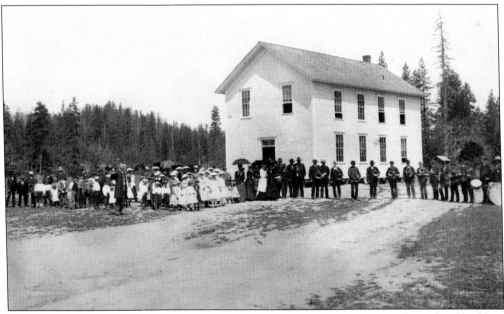

Grants Pass Academy, also frequently called the Central School, was originally a school building erected in Jerome Prairie in the 1870s but rebuilt between Third and Fourth and B and C Streets in 1884. Classes increased rapidly, and a wing was added in 1886 along with a bell tower and a new bell cast in St. Louis, Missouri. All grade levels attended classes at the building. Some of the older students even boarded in town so they could attend high school.

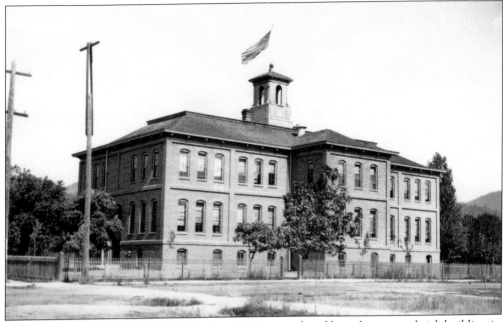

The first substantial school building built in 1884 was replaced by a three-story brick building in 1890. Grants Pass High School was on the top floor with the eight elementary grades below. The old wooden building was dragged across the street and was the Pine Needle Factory, after which it stood derelict and empty, making it a good place for vagrants to sleep in since it was just two blocks from the railroad tracks. It was dismantled, and houses were built with the wood. One house still stands on C Street with wood well over 140 years old.

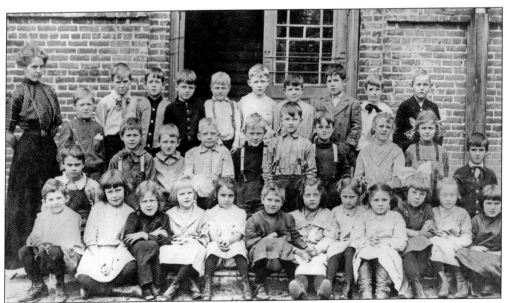

The first-grade class at Central School in 1911 poses for a class photograph. The sixth girl from the right in the first row is Bertha Calhoun; she spent her adult life teaching school in Grants Pass, ending her teaching career as dean of girls at Grants Pass High School.

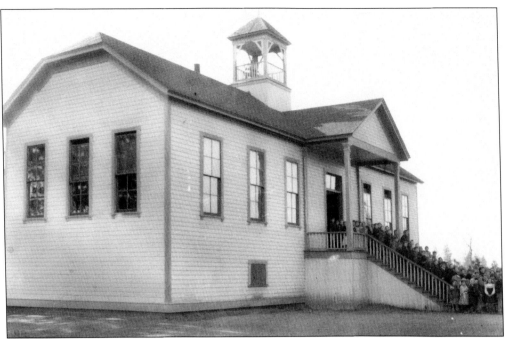

The Fourth Ward School was built as a short-term overflow school at the end of Fourth Street across from where M and Bridge Streets join. The building housed a school for seven years from 1899 to the spring of 1906. It had three classrooms and soon became overcrowded. By January 1903, a classroom had opened in the city hall on Sixth Street, and a second classroom was opened. The students used to annoy the jail inmates and probably vice versa. Two schools, Eastside (later Lincoln) and Riverside were built. The South Ward School was used for storage and finally in November 1910 was sold and converted to the Smith Apartments. The building burned down in 1928.

Eastside School was built at the turn of the century when Central School became overcrowded. It was located on Seventh and School Streets and opened on October 17, 1903. It was a two-story brick building with six classrooms with a design to which classrooms could be added without disrupting the symmetry of the building. When Roosevelt School was built two decades later, the students were allowed to rename the schools; Eastside became Lincoln School, and Central School became Washington. However, Riverside stayed the same.

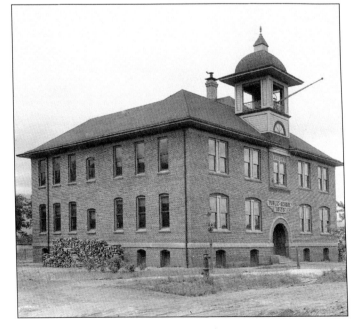

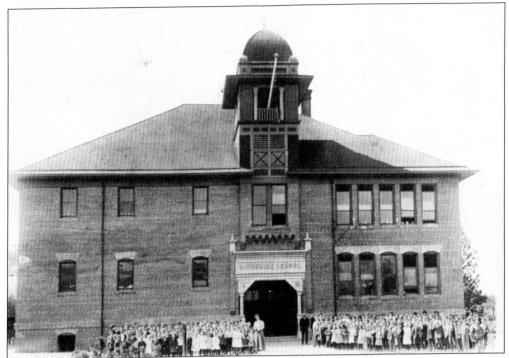

Riverside School on the south end of Seventh Street was built in 1906 and opened in September 1906. Students from the Fourth Ward School were shifted to Riverside along with the two classrooms that had been in the city hall. Riverside had eight classrooms. All the furniture from the Fourth Ward School and the city hall was moved to Riverside and filled five of the eight classrooms. The school bell also went from Fourth Ward to Riverside.

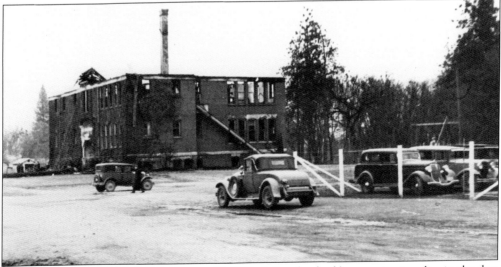

Riverside School burned down February 23, 1937. A flue fire had been put out earlier in the day. It was undetermined if it ignited again or if the fire was caused by an electrical problem. Within a week of the Tuesday destruction of Riverside School, students were walking north to attend classes at Lincoln in the morning, with Lincoln students attending in the afternoon. Students were expected to have lunch at home. Double shifting lasted until the new school was built.

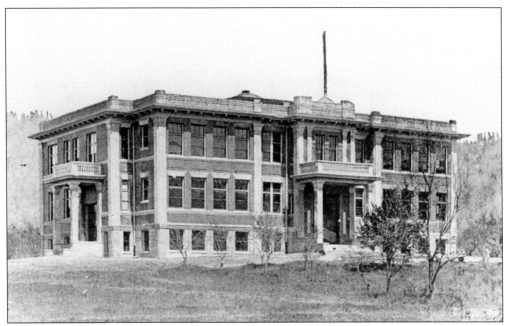

Grants Pass High School left Central School in February 1911 for a building of its own. It was built on Olive Street, between Eighth and Ninth Streets, on a knoll, which could be seen from most of the city. As trees grew and the school went through many changes, including lowering the hill, the building was less visible from around town. The 1911 building was a three-level edifice of redbrick, trimmed in white.

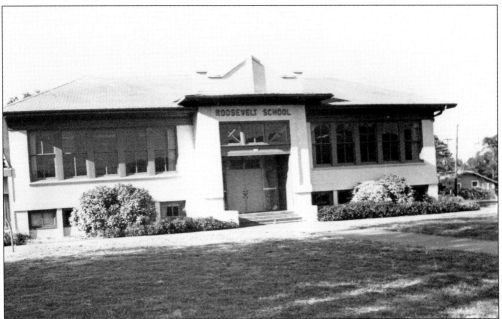

When the Fourth Ward School closed and students transferred to Riverside, a promise was made that a new school would be built in southwest Grants Pass. It took 16 years before the new school, Roosevelt, was finally opened on Southwest G Street. The school operated until 1977. The building still exists.

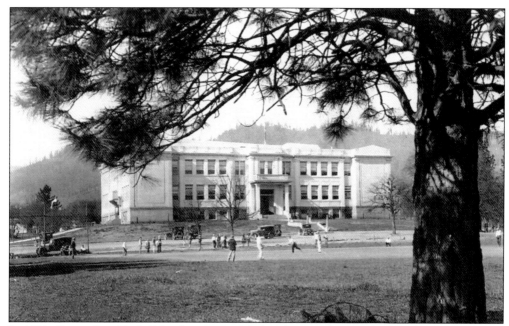

In 1924, Grants Pass High School was remodeled with wings built at both ends, and the entire redbrick structure of the original building was covered with white stucco. A football field was established in front of the school across Olive Street. This photograph was found in the archives of the Gold Hill Historical Society and donated to the Josephine County Historical Society in 2011. The pillars at the front entrance were buried at the northeast corner of the football field when the school was extensively remodeled in 1948. When a new school was under construction in 1995, the pillars were rediscovered. A bigger, deeper hole was dug, and they were buried again.

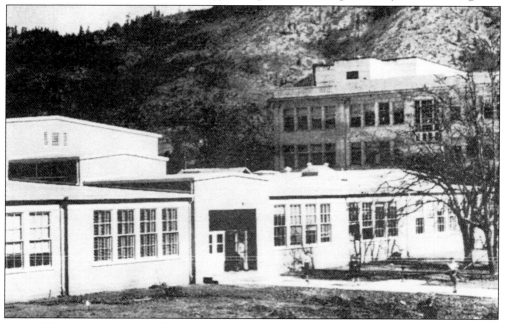

A new GPHS was built downhill from the old school in 1939. It was a one-story building. The old high school was up the hill to the right of the new building and became the junior high.

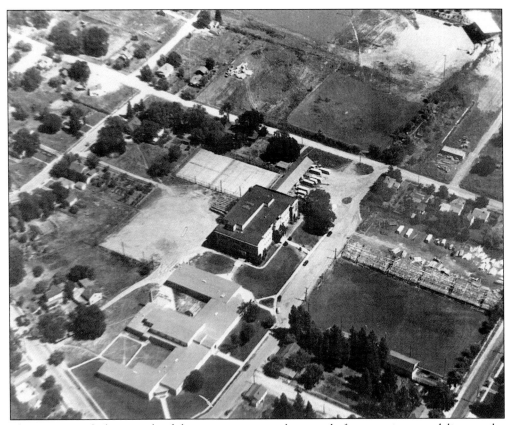

This is an aerial photograph of the previous view, taken just before a major remodeling on the school started. To the right, a new grandstand is shown under construction around 1947. Much of the lumber for the grandstand came from Camp White, located north of Medford, when it was decommissioned after World War II and over 900 buildings were sold, moved, or dismantled. The old Army camp is now called White City.

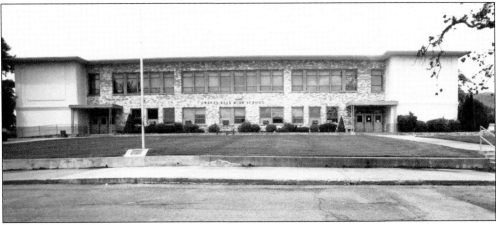

In 1948, still on the same site and knoll, a newly remodeled GPHS shows what can be done when dirt is pulled away from the daylight basement and the third story removed. The high school students took possession of the new building, and the junior high students went to the 1939 single-story high school building.

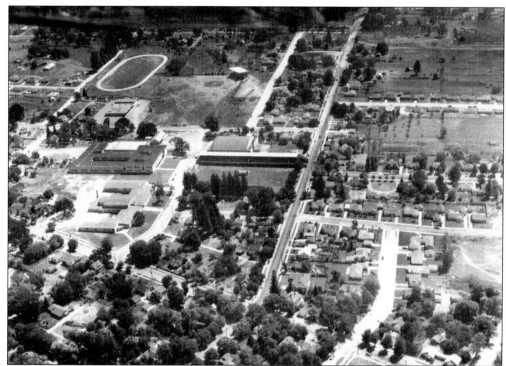

About 1950, the "new" GPHS, grandstand, and Memorial Gym stand on the same campus, but several feet lower because the daylight basement became the first story when the dirt was removed around the base. All of this started to disappear with an arson fire that destroyed the grandstand in 1988. All these building have disappeared, and a new campus stands on the original site.

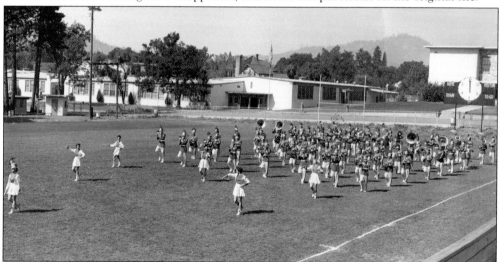

Gale Jones, longtime GPHS photography and social studies teacher, took this photograph of the GPHS band practicing on the football field. Grants Pass Junior High is in the background with the newly remodeled high school to the right behind the football clock. Eventually, South Junior High was built in 1968, and this building became North Junior High. A new school was built on Highland Avenue, and it became North Junior High and then North Middle School. This 1939 building became the English building for Grants Pass High School.

Three

MERCHANTS

Some early merchants had the foresight to photograph their businesses. Some of those photographs have been preserved. Banks, hotels, hardware stores, clothing stores, saloons, and boardinghouses grew up rapidly in Grants Pass. The first buildings were wood, and many were destroyed by two major fires in 1894 and 1902. The city council decreed that all future business buildings in the core of town needed to be built of brick.

The first brick building was built on the southeast corner of Sixth and G Streets in 1886. Some of the remaining buildings were built prior to 1902 and survived the fire. Although gutted by fire, they were salvaged and interiors rebuilt.

It was very common for the owner or builder to put his name on the building and the year it was built. Sometimes the year of construction was affixed a couple of years before the building was finished and ready for occupancy. Over the years, as fancy facades and parapets have been removed, the dates have vanished too.

Merchants established businesses to meet the needs of not only the city of Grants Pass but also the many little towns in Josephine County. As the county seat and a division point for the railroad, with a roundhouse and railroad warehouse next to the freight depot, much of the shipping of goods, both into town and out of town, centered at Grants Pass.

Merlin, Hugo, and Wolf Creek, towns north of Grants Pass, had railroad stations, but most of the rest of the county used Grants Pass as their shipping point.

In the beginning, the merchants offered necessities, but as the town grew, culture came to the city when the opera house was built and later when motion pictures arrived. From the beginning, there had been a city band comprised of men who could play musical instruments.

This chapter shows representative businesses throughout the years along with the changing facades of the main street. Some businesses took many photographs and saved them and gave copies to the Historical Society. Others were too busy building the business to worry about such things.

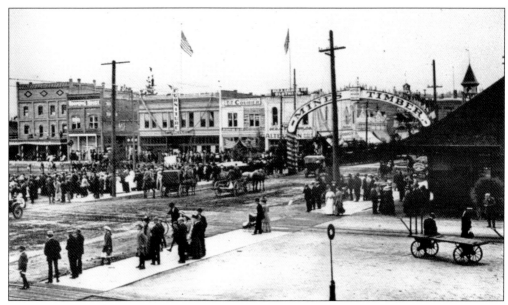

In 1905, G Street between Sixth and Seventh Streets had a row of sturdy buildings, including, from left to right, the Grants Pass Hotel with the diamonds on the upper facade, and a rooming house with words "Rooming House" painted at the top. This was the building that operated as the Southern Oregon General Hospital in 1906. Next is a furniture store, the *Courier* newspaper's offices, and the first brick building on G Street, which housed the Calhoun clothing company. North, across the street, was Railroad Park.

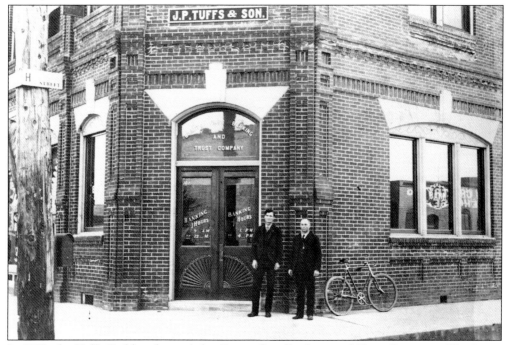

In 1905, the Tuff's Building housed the Grants Pass Banking and Trust Company. The hours posted on the doors were from 9:00 a.m. to 12:00 p.m. and 1:00 p.m. to 4:00 p.m. L.L. Jewell (left) and Eclus Pollock stand in front of the building. Note the street signs on the power pole.

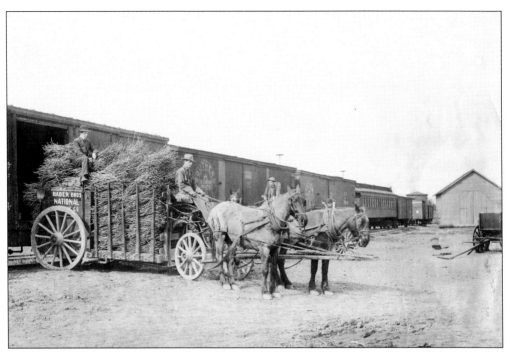

Automobiles came to Grants Pass in 1904, but many did not own one for years. The Baber Brothers National Hay Company loads hay onto a boxcar for shipment elsewhere. Baled hay had not yet arrived in Grants Pass.

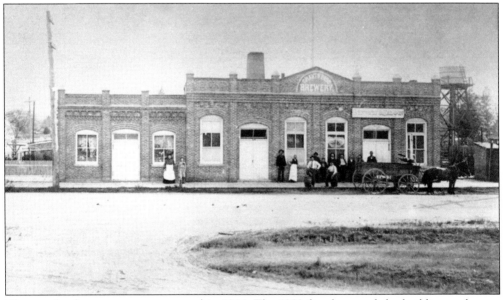

The wooden brewery was constructed in 1886. The 1902 fire destroyed the building and many of the other buildings on G Street. Eugene Kienlen had just purchased the business in 1901 and had to rebuild the structure of fireproof brick in 1902. In 1908, the city passed a local prohibition ordinance and stopped the sale of alcohol. The building housed many businesses, including a saddle and harness store, a granary, a grocery store, a warehouse, an art galley, and a restaurant. It is located on Gilbert Creek on G Street just west of Fourth Street.

Cramer Brothers Hardware Store was on the corner of Sixth and H Streets in 1907. It was located in the corner portion of the IOOF Building. Cramers sold Garland cook stoves, shown to the left in the photograph.

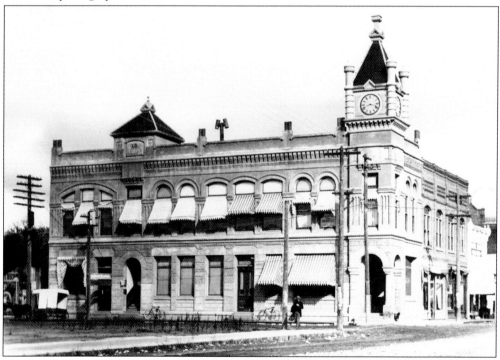

The First National Bank Building still stands but without the exterior decor. In 1926, the building was expanded on Sixth Street (right) by extending the same facade over the first two windows of the adjacent building. The cupolas were removed, and about 50 years later, the bottom windows along F Street were eliminated and a solid wall built. The metal plates that covered the building were removed, and the entire building was covered with stucco.

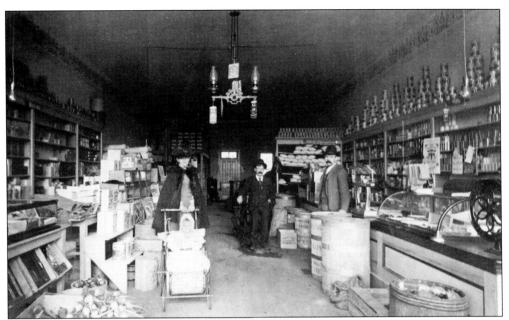

In 1901, Claus Schmidt stands next to his counter in the grocery store that was located on the west side of Sixth Street, between H and I Streets. The building no longer exists. His wife, Hannchen Schmidt, stands with her infant son Reinhold in the baby buggy. The man in the middle is unidentified. Later, Schmidt built his own large building for his grocery store on the southwest corner of Sixth and I Streets.

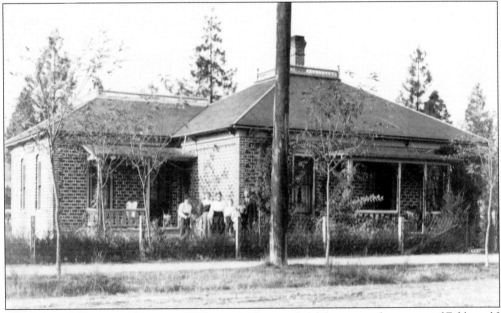

The Schmidt House was begun in 1899 as a single-story brick house on the corner of Fifth and J Streets. Claus Schmidt operated a grocery store in Grants Pass. By 1911, the house was a completed two-story house with wooden shakes covering the second story. The Schmidt House Museum is operated by the Josephine County Historical Society. This is one of the private residences that was just one block from the main street and still survives.

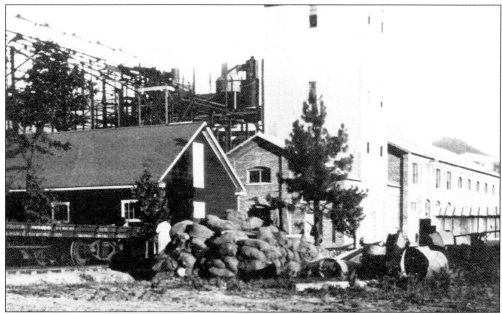

The railroad tracks came up to the sugar beet factory. A flatcar can be seen to the left. All equipment was in place for a successful operation, but sugar beets could not be grown in the quantity needed. The factory was located in Fruitdale, south of the Rogue River where the Fruitdale Grange is located.

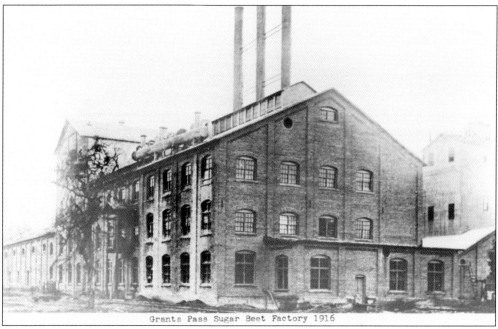

Pictured in 1916, the Sugar Beet Factory brought high hopes and Mormons to Grants Pass. Soon, it was determined that without a good irrigation system, the sugar beets would not grow large enough crops to keep the factory open. It lasted two seasons and was then torn down and moved to the state of Washington. Many of the Mormon families who came to build and work in the factory decided to stay in Grants Pass.

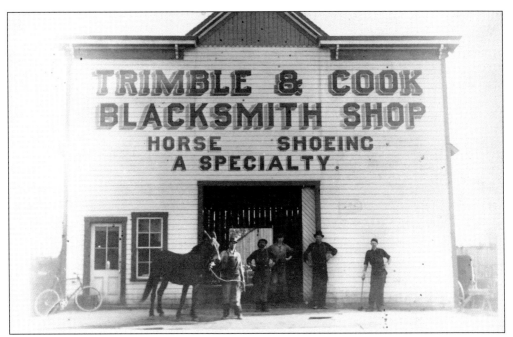

The Trimble and Cook Blacksmith Shop stood behind the Schmidt Grocery on I Street. As time passed, it continued to service farm animals but started to convert to auto repair.

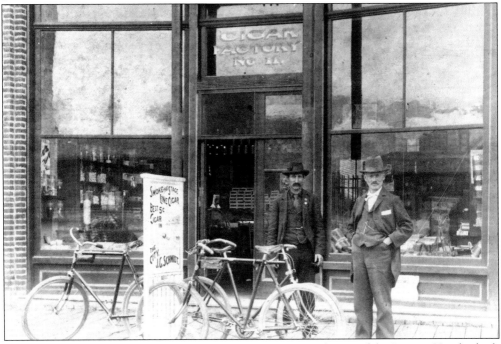

J.C. Schmidt's Cigar Factory was built on G Street in 1894 on the site of the Pioneer Hotel, which burned in the January 1894 fire. The elder Schmidts operated a cigar and candy store in the building for many years. When the elder Schmidts died, the younger members of the Schmidt family changed the name of the business to the Pastime Cigar Store. The final name was the Pastime Tavern, which was closed in 1993 after operating for 99 years.

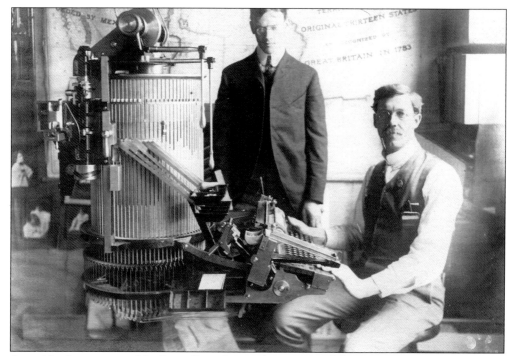

Amos Voorhies, owner of the *Rogue River Courier*, later renamed the *Grants Pass Daily Courier*, sits at the keyboard of the typesetting machine. Amos Voorhies was an avid photographer and from the shadow to the right of his shoulder, this may have been a time exposure he took of himself.

About 1903, the boardinghouse offered rooms with meals and meals without being a resident of the boardinghouse. It was located on the corner of Fourth and G Streets. Next door, the brick building was a grocery store, which had been built in 1902 after a fire destroyed much of G Street. Upstairs was a private residence and remains so over 100 years later. The front of the building has cast-iron columns, which had Grants Pass Ironworks cast into them when they were manufactured.

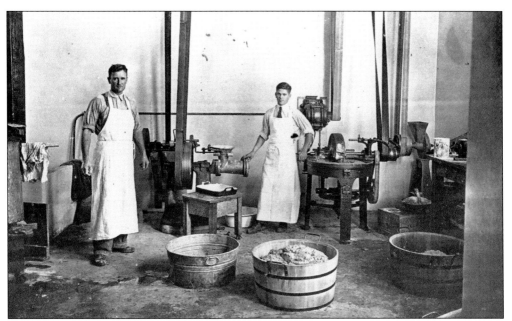

Laurence Bureau and Emil Harbeck grind hamburger at the City Meat Market. Automation left the old hand-ground method behind in favor of meat grinders attached to a central motor and the overhead pulley system with wide leather belts.

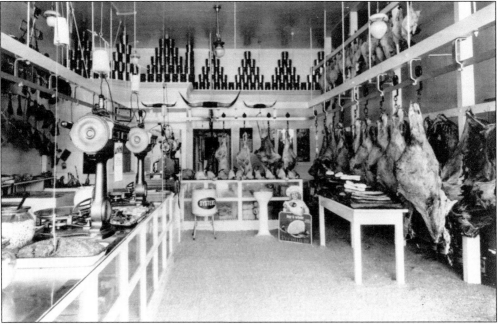

The City Meat Market on G Street processed the animals from slaughter to the table. Sawdust was strewn on the floor to help absorb whatever leaked off the carcasses. Note the fowl hanging above the beef. Customers could buy meat at any stage of processing, such as taking a chicken with feathers home. Although Grants Pass had electrical power starting in 1889, most citizens did not have the capability of keeping meat at home for an extended period of time and a daily visit to the butcher was common.

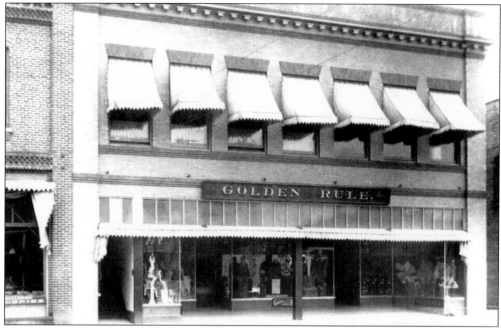

Built as the city hall with a cupola, this building was remodeled in 1912 for the Golden Rule department store. The cupola was removed. The entire front of the building was redone to make it a storefront instead of the fire department. The Golden Rule moved out of the Tuff's Building and across Sixth Street to the new store.

The Golden Rule store celebrated its 25th anniversary in 1930. In the back of the store to the left is the ramp that went to the mezzanine and then to the third level. The Golden Rule was a well-stocked department store on three levels. The ground level had yard goods, shoes, and men's apparel. The mezzanine held the restrooms, infant wear, draperies, and remnants. The second floor (third level) was ladies' ready-to-wear, millinery, and corsets.

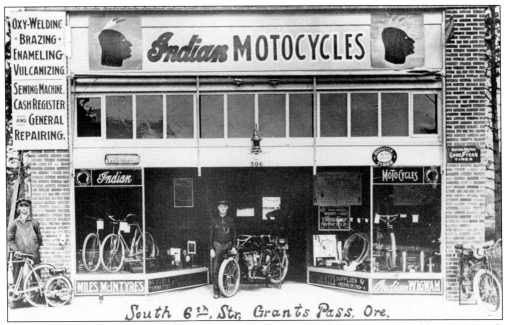

Motocycles (motorcycles), pedal bicycles, and motor-powered bicycles were sold at 506 South Sixth Street. This business offered sales and repairs of many items, from cash registers, bikes, and typewriters to sewing machines in 1915.

In the summertime, the hamburger stand near Railroad Park had a thriving business. This was Grants Pass's first "fast food" restaurant and operated in the 1920s and 1930s.

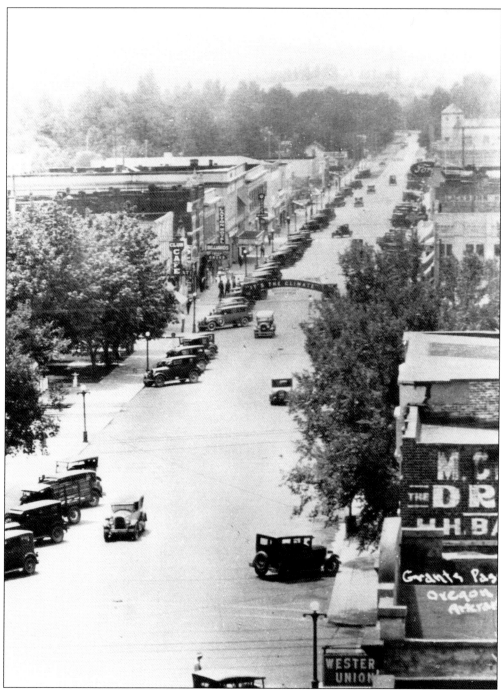

Taken between 1927 and 1931 from the tower of the Redwoods Hotel, this photograph is unique because the angle of the image and the foreshortening of Sixth Street make the railroad crossing almost invisible. The tracks are barely visible crossing the sidewalk at the center left of the photograph where no cars are parked along the curb. Because the street was constructed very wide in the 1880s, cars could park diagonally along Sixth Street and still have plenty of room for traffic. Note the "It's the Climate" sign just past G Street.

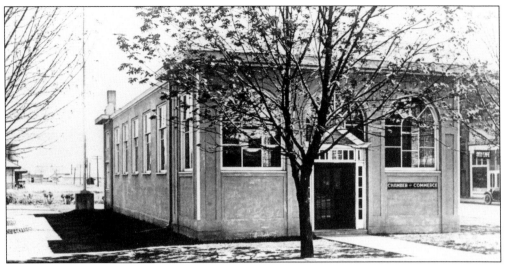

The Chamber of Commerce Building was located on the northeast corner of Sixth and G Streets in a grove of trees where Railroad Park had been located for years. Built in the 1920s, it was just below the "It's the Climate" sign; the arrow that asked tourists to "Register Here" pointed to the building. The Chamber of Commerce Building was constructed by Gus Lium, the local builder who is most noted for building the Oregon Caves Chateau.

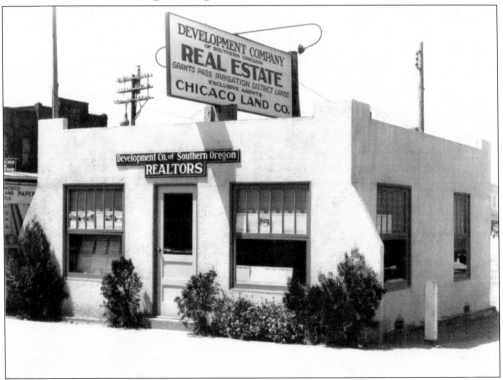

The Chicago Land Company came to Grants Pass with the building of Ament Dam in 1902 and continued with the building of Savage Rapids Dam in 1921. In 1926, the Chicago Land Office sat near the northwest corner of Sixth and G Streets. Pictured just to the left of the building is Blind George's Newsstand, and part of the Pastime Tavern sign can be seen across G Street.

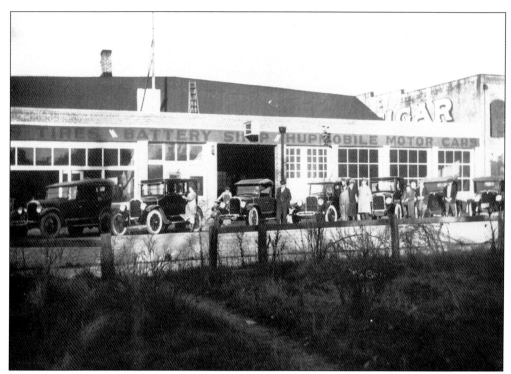

The Hupmobile dealership lost clients when Hupmobile switched from a four-cylinder auto to an eight-cylinder around 1925. Bill Carnahan ran the old Hupmobile dealership, the garage on the corner of Fourth and H Streets, as a GMC and Buick dealership. He also reconditioned and repainted automobiles, sold Associated gas, provided service for Studebakers, and towed and stored automobiles.

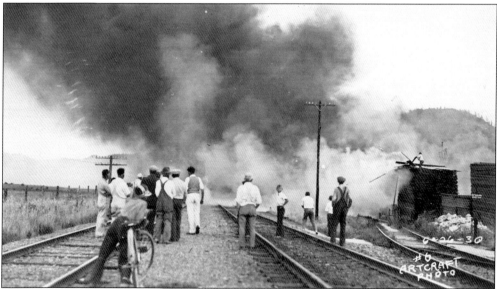

The box factory fire dealt a blow to the local economy when it burned on June 26, 1930. Many of the trees harvested were used to construct boxes to pack and ship fruit out of the valley. This was still the era of wooden boxes as cardboard had not replaced wood at this point.

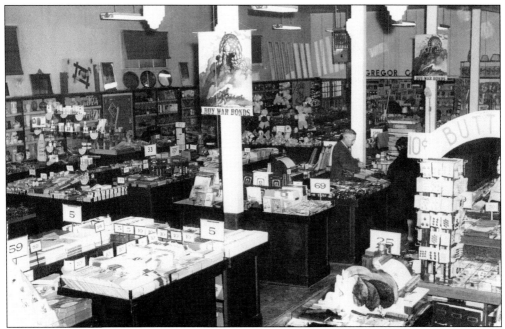

McGregor's Variety Store was on the northwest corner of Sixth and I Streets from 1939 to 1986. Don McGregor is shown waiting on a customer around 1942. Stores like McGregor's were often called dime stores or five-and-ten-cent stores. McGregor's was the primary dime store in Grants Pass from the 1940s to the 1970s.

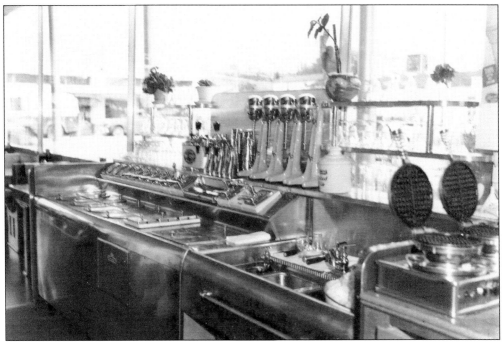

Nandies Café, near the corner of Sixth and M Streets, was a Grants Pass restaurant for many years, located first on the block between G and H Streets and finally on Sixth and M across from the Piggly Wiggly grocery store, which can be seen through the window.

A modern building constructed in the 1940s housed Nandies Café on the left and Robert C. Martin's Studebaker dealership on the right. Robert C. Martin served as mayor of Grants Pass from 1953 to 1959 and was an avid photographer.

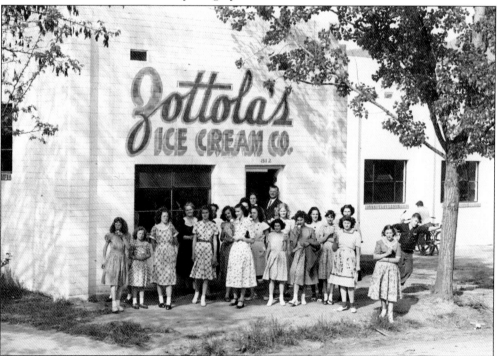

This location of Zottola's Ice Cream Co. opened about 1946. The address was 812 Southeast H Street. Note the girls all have on dresses, the younger ones with bobby socks. Standing in the doorway is Paul Border, the ice cream maker.

Four

Activities for the Public Good

The earliest forms of recreation dealt with agriculture, such as the Josephine County Fair. The fairs were held all over the county under different names. A fairgrounds complex was built south of the Rogue River, and the city of Grants Pass grew up and out to meet it. Recreation simply for having fun came into being with the building of a city park, located just outside the business district on the south side of the river and east of the Grants Pass Diversion Dam, which was built to provide electricity in 1889. The backwater of the dam created a nice swimming area at the city park. A bathhouse, river raft, wooden pier, and slide occupied the city park, later renamed Riverside Park. It was a good place to swim and sun until polio hit the region in the 1940s.

It had been rumored for years that Grants Pass sat upon a large source of gold, but no one bothered to look into the matter after the town had been constructed. People were content to let their town stand and not be riddled and washed away by mining like many other little mining towns. The Aments built a dam to placer mine three miles east of town, but eventually, the dam served the city's drinking water and irrigation needs rather than placer mining. Mining was important in the county but began to wane at the outbreak of World War II when the federal government asked most large mining operations to close.

Agriculture was a large part of the growth of Josephine County, and produce that shipped out of the area was sent from the railroad depot in Grants Pass. The lumber industry developed extensively during World War II. Logging provided logs for the lumber mills. Lumber mills were located throughout the county with some around the perimeter of the city. As more and more trees were harvested, the lumber business declined for lack of raw material.

City bands were formed, and students formed bands outside of school. Music education eventually became part of the school system, and students could start to learn to play a musical instrument in elementary school.

The vast majority of photographs on file at the Josephine County Historical Society that can be identified deal with the growth of the community, like its businesses, recreational activities, community gatherings, parks, and parades. Even those that can be identified as to place and approximate time are not always identified by what the event was all about.

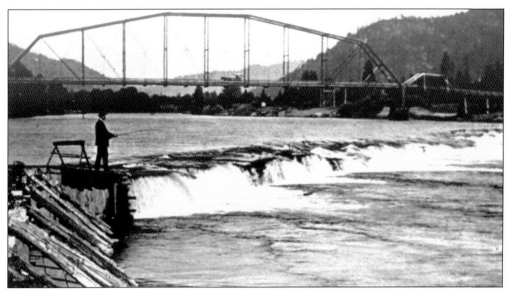

The Grants Pass Diversion Dam was built in 1889 to funnel water to the north side of the Rogue River into a channel that flowed to a water wheel, which in turn generated power for the city until the Condor Dam, later named the Gold Ray Dam, east of Gold Hill, Oregon, came on line in 1905. The old dam was kept up to provide a recreational lake for the city park. In the 1940s, when polio hit the area and swimming at the city park was greatly curtailed, the dam no longer functioned. Over the years, the remaining wood washed downstream, but there is still a "bump" in the river where it once stood.

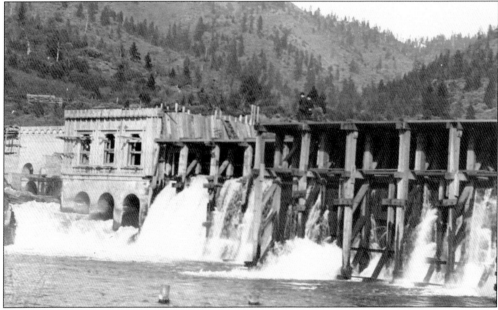

The Golden Drift Dam was started in 1902 as a source of water for placer mining. By 1911, it was called the Ament Dam and had been raised to the height shown here. It was constructed of 12 by 12 timbers forming cribs in which rocks were placed. The mining company failed, but the water was piped into Grants Pass for irrigation and human consumption. It was three miles upriver from Grants Pass. Damaged by high water over the years, most of it washed downstream.

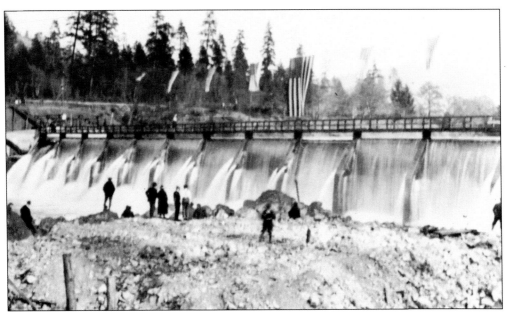

Flags were strung across the Rogue River above the newly operational Savage Rapids Dam at the dedication on Saturday, November 5, 1921. Savage Rapids was built to provide water to the valley. There was a wooden walkway across the dam, and people could picnic alongside the river. Savage Rapids Dam was removed in 2009, and rafters anticipated rafting the savage rapids. Savage Rapids and the dam were named after the Savage family who homesteaded in the area, and neither the family nor the rapids were savage.

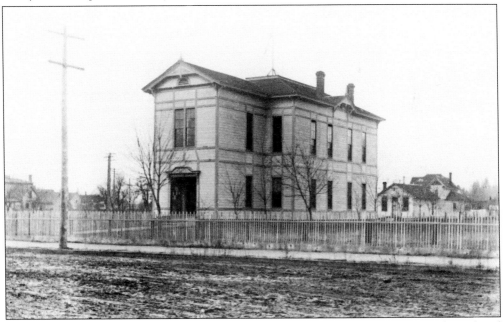

The first courthouse in Grants Pass was built shortly after the county line was adjusted and Grants Pass was no longer in Jackson County but in Josephine County. Around 1885, Grants Pass ran against Kerby and Wilderville to seek the county seat position and won the honor. The courthouse was built within months.

The city hall stood on Sixth Street on the east side between H and I Streets from 1894 to 1912. It housed city offices, the jail, and for a while, a couple of elementary school classrooms. The Golden Rule store removed the cupola and remodeled it for its department store in 1912.

In about 1894, the local firemen posed with their dog, hoses, and nozzle. The names were put on the back of the photograph many years later, and those pictured are, from left to right, (first row) Burt Warren, August Fetch, Ralph Hutch with dog, George Slover, and George Hartman; (second row) unidentified, Fred Chesseur, Harry Peterson, George Charles, and Fred Welch; (third row) unidentified, Will Taylor, and George Bacher.

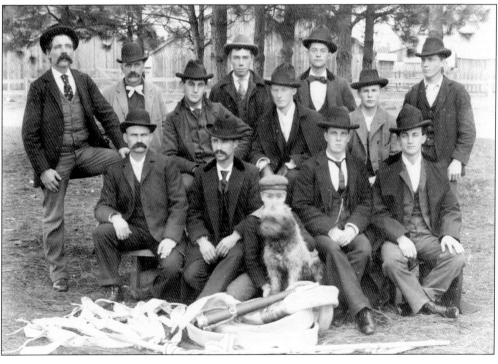

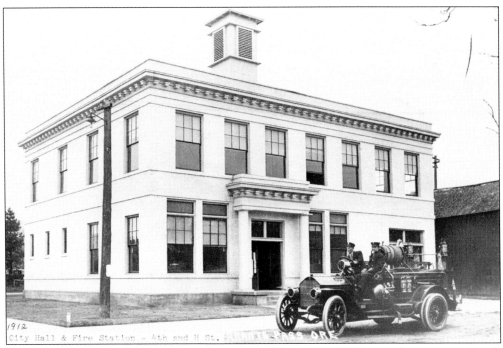

The new city hall opened in 1912 at the corner of Fourth and H Streets. It was covered with white bricks on the front and sides. The backside was (and still is) standard redbricks. The white bricks were made in Yamhill County and shipped to Grants Pass.

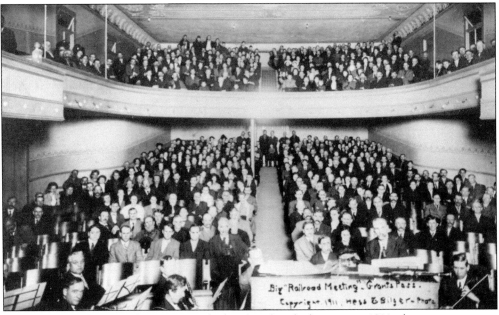

The interior of the opera house was packed with railroad advocates in 1911 when a meeting was held to discuss the building of a railroad from Grants Pass, Oregon, to Crescent City, California. The railroad was started, but only made it to Waters Creek about 14 miles west of Grants Pass. The internal-combustion engine and the automobile pushed the completion of the railroad aside when a highway was constructed between the two cities.

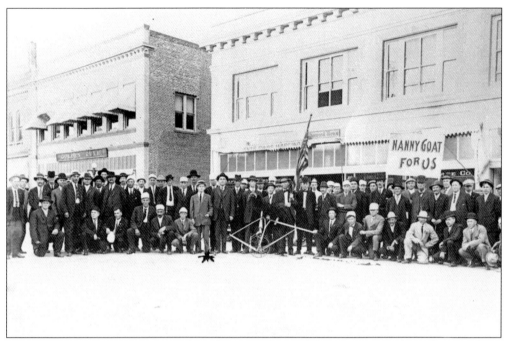

On June 7, 1915, the local membership of the Woodmen of the World posed for a photograph on Sixth Street between H and I Streets. The significance of the sign "Nanny Goat For Us" may have something to do with the 1915 published ritual of the Woodmen that had a list of all the articles used in the ceremony, including a goat. A mechanical goat was used by some Woodmen groups, so the object in the center may be the goat.

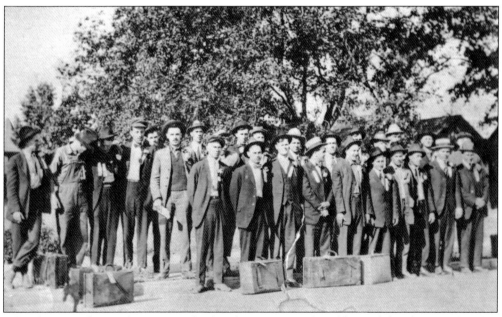

After the United States became involved in the Great War (World War I), local men enlisted to serve in Europe. This photograph was taken of the local enlistees in 1918.

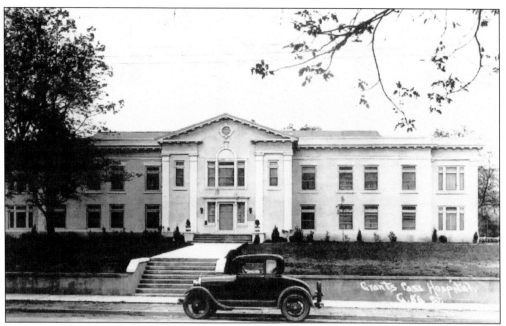

Grants Pass had many small hospitals over the years, but in 1929, the first building dedicated to being a full-time medical facility opened on A Street at the top of the hill. Some locals even referred to the site as "hospital hill."

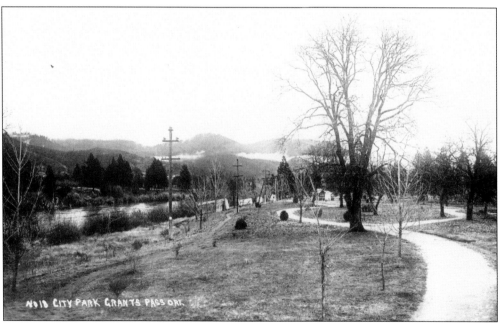

The city park was opened just over the bridge. It was a sparsely treed area in the beginning. It was gated and closed at night. The Grants Pass Diversion Dam was downstream, and a shallow lake was formed at the park. There was a marina and boats to rent. In the 1930s and 1940s, it also had campsites and cabins. During those times, many people moving to Grants Pass spent their first few days at the city park. It was later named Riverside Park.

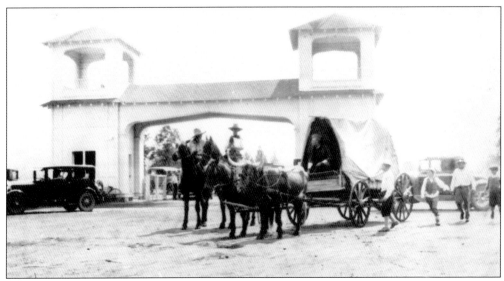

For many years, the Josephine County Fairgrounds had two towers joined by an arch as the entryway. After the 1956 fair, the gateway was demolished because it was becoming unsteady after years of use.

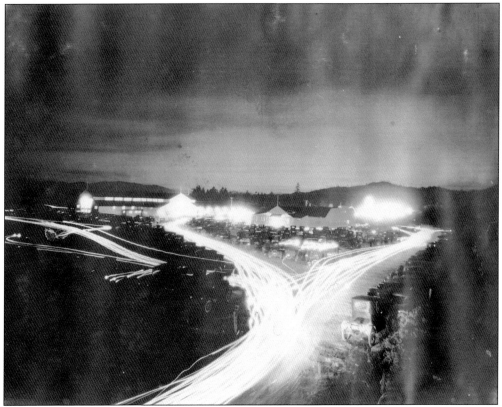

Fairs were situated all over the county in the early years, and then, the Josephine County Fairground was built on Highway 199 just outside the city. This time exposure shows the exodus from the fairgrounds at night.

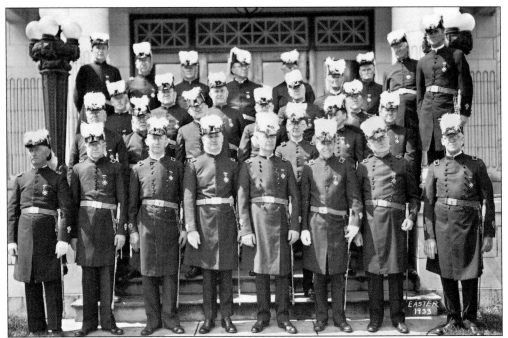

Most of the organizations in Grants Pass were service-oriented, but that did not mean they did not have uniforms or costumes. On the courthouse steps in 1933 at Easter time, members of the Knights Templar pose for their yearly photograph. Those in the first row are, from left to right, L.M. Mitchell, W. Clarke, George Riddle, Charles Cooley, P.B. Herman, Sam Stinebaugh, Sam Baker, and A.E. Voorhies.

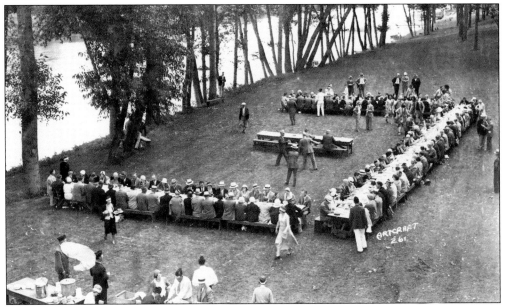

When the Caveman Bridge was dedicated in 1931, it was a time for celebration. After three bridges, it was hoped that the concrete structure would be the last one for some time to come. The event was celebrated by a sit-down luncheon in Riverside Park. A wait staff served them, and the Oregon Cavemen can be seen in their furs in the upper-right corner of the tables.

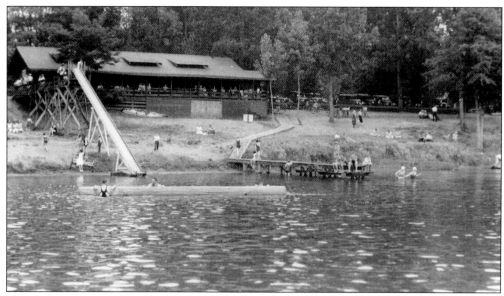

This bathhouse was at the city park until the summer of 1936. The city decided to tear it down and build a new building, which it did in a couple of months. The Grants Pass Diversion Dam, no longer used to help generate electricity, was still maintained so the river along the city park remained deep enough to swim during the hot summer months.

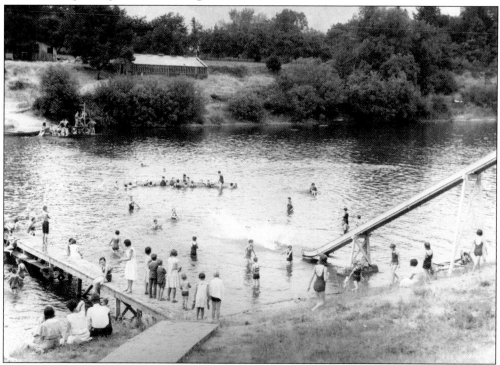

When the old bathhouse was demolished, a new one was built very quickly. The small dock and water slide were also removed and never replaced. The large wooden raft anchored in the center of the river remained. Sand was put along the bottom of the river for easier walking, and the dam held back the water and kept the sand from washing downstream.

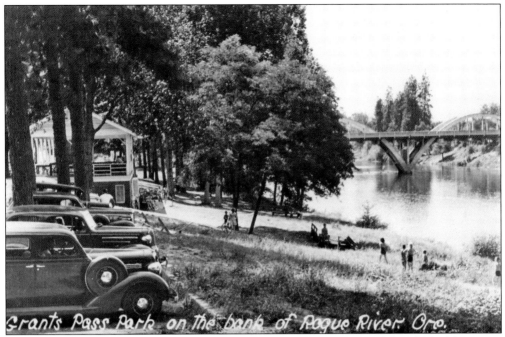

The new bandstand with changing rooms on the ground level replaced the old bathhouse, as seen in this 1937 photograph. A whole new use developed for the area with band concerts in the park. By the 1940s, the new bathhouse was used less and less because polio became a concern and parents did not want their kids to play in the water.

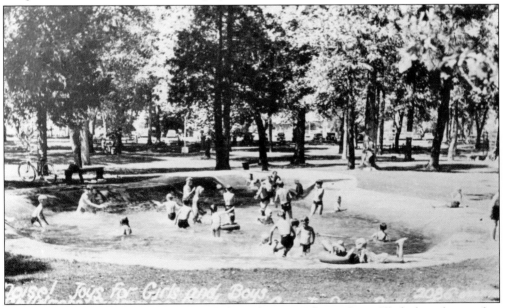

The children's "wading pool" was set back from the river. The pool was filled when the weather got warm, and water was added daily. A man from the park would come around several times a day, ask all the kids to vacate the pool, and take water samples. One of the children remembers the man looking at the test results and walking away shaking his head. Soon, it was closed because of the fear of contracting polio.

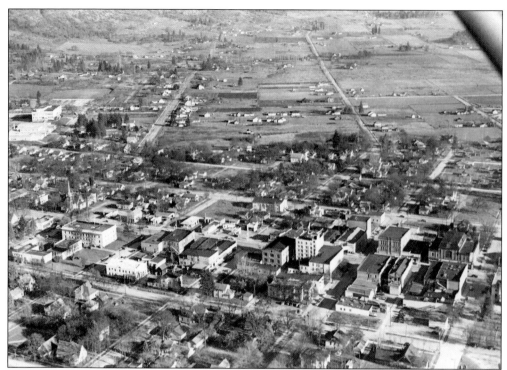

This view of Grants Pass from F Street north and east shows a panorama of the city between 1939 and 1948. In the upper-left corner, the two school buildings can be seen. The single-story Grants Pass High School was built in 1939, and the old three-story building was not remodeled until 1948. Both those buildings are gone. Starting with the steeple of the Methodist church, remaining buildings, as well as those long gone, can be seen.

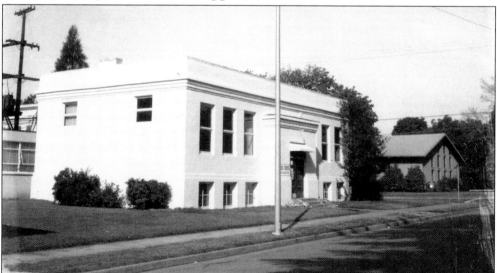

The old library had a ground-level entrance, but once inside, stairs led up to the adult portion of the building and down to the daylight basement for the children's section. The stairways and all the bookcases were dark wood, making the rooms look dark because all the walls were lined with bookcases.

The "modern" Josephine County Courthouse was built in 1916 on the site of the original courthouse. This photograph was taken in 1948 when Thomas Dewey, the Republican candidate for president of the United States, made a campaign stop in Grants Pass. His campaign bus was stopped north of town, and he was "kidnapped" by the Oregon Cavemen, who delivered him to the courthouse steps and then disappeared from the scene.

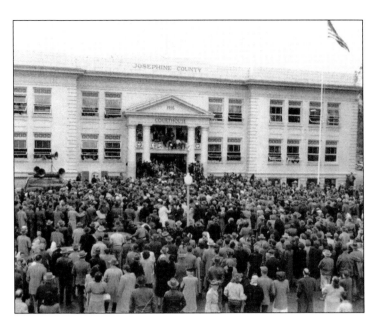

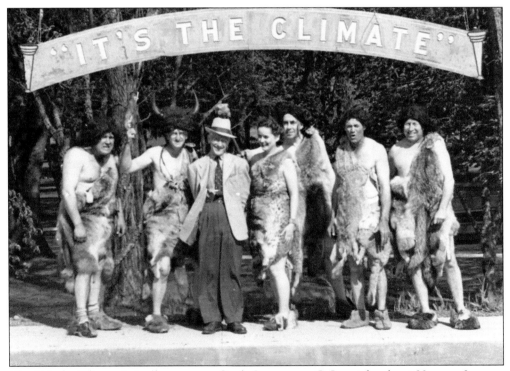

The "It's the Climate" sign hung across Sixth Street near G Street for about 20 years. It was a wooden sign and was removed in 1941 and taken to the city park where it soon deteriorated and was taken down. As the story goes, it was stored in the bottom level of the bandstand and was eventually destroyed in the flood of 1955. The Oregon Cavemen, a local group of men who dressed as cavemen, are shown here at the rededication of hanging the sign in the park.

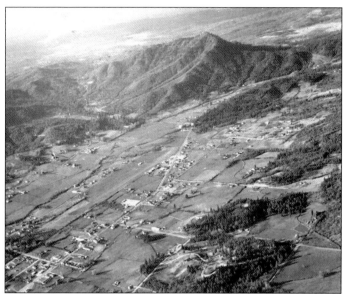

The Grants Pass Airport was north of Grants Pass and situated next to the Pacific Highway (Highway 99). This photograph shows the airport runway to the left, with the highway running north to the right of the airport. Planes approached from the south, flying over the city and landing facing north under most circumstances. In the early 1960s, a new airport was built north of Grants Pass, beyond Merlin, which can be seen on the other side of the hill in this photograph.

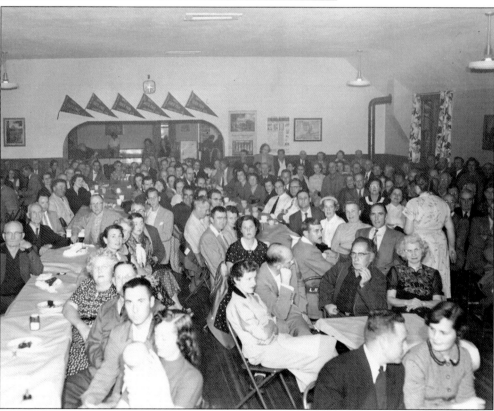

This sea of faces was photographed in the 1950s from the stage of the Fruitdale Grange Building. What the meeting was all about has been lost to history since no one bothered to identify the circumstances. Debbs Potts is sitting at the end of the first table to the left; he served as mayor of Grants Pass and also as state senator, so it may have been a political meeting or just a big grange potluck dinner.

Five
TRANSPORTATION

Grants Pass began to grow with the arrival of the railroad. Before it, there were trails throughout Josephine County, and some could be traveled by wagon, mule trains, and stagecoaches, but others were suited to a single horse or a man on foot. Downtown Grants Pass was surveyed early so inhabitants could get across town with ease from the very beginning. When the automobile arrived, the muddy streets quickly became a quagmire of mud and deep ruts. Paving of the streets became a priority, and the main road through town, Sixth Street, was paved in 1910; soon after, the side streets were given a macadam (blacktop) surface.

Whether to build a road or a railroad was the question in the early 20th century. It seemed that everyone wanted to build a railroad because the highways were either nonexistent or impassible in the winter. Freight and supplies could come in by rail, but very few people were brave enough to venture outside the city by automobile. That changed very quickly.

There were railroads surveyed to Jacksonville, Williams, the Northern California Coast, and various other short railroad line plans departing from Grants Pass. The only one that even got started was the one to Crescent City, named the Oregon & California Coast Railroad. It only made it to Waters Creek, just a few miles past Wilderville. The portion in California made it 12 miles east out of Crescent City. They never connected because Highway 199 was completed .

The completed portions of the railroad were used to haul lumber into Crescent City from the redwood forest and lumber and ore in Josephine County. Chrome, gravel, and assorted ore-bearing soil were shipped from Wilderville to connect with the Southern Pacific Railroad in Grants Pass. The Ideal Portland Cement Company in Gold Hill mined Marble Mountain and constructed its own rail line down from the quarry to the O and C line near Jerome Prairie and shipped the ore to Gold Hill to be processed in the 1930s and 1940s. When the railroad bridge across the Rogue River was washed out in the 1955 flood, the railroad venture that only built 14 miles of track in 40 years was ended.

This section shows the modes and manner of transportation and businesses served in Grants Pass.

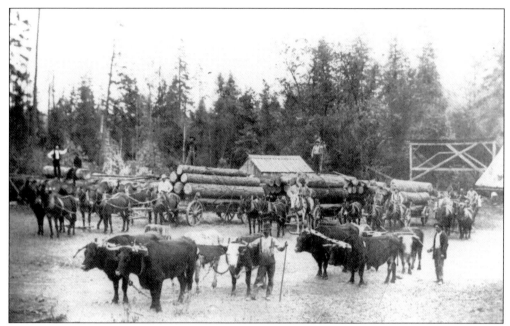

Oxen and mules were the main power for moving heavy items in the early days of Grants Pass. Horses were used for lighter work and pulling the buckboards or surreys. A logging team with both mules and oxen and the horse wagon to the side all lined up for a T.A. Lee family business photograph.

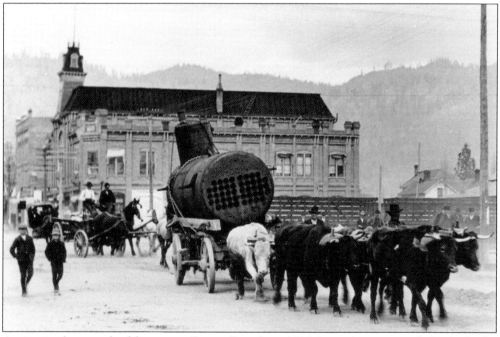

An iconic photograph of downtown Grants Pass about 1903 shows the moving of a big boiler for the Nipper-Johnson sawmill at Murphy, Oregon. It arrived in Grants Pass on a railcar and was set aside on cribbing timbers for several weeks until the mill men brought in a mill wagon and six oxen to haul it to the mill.

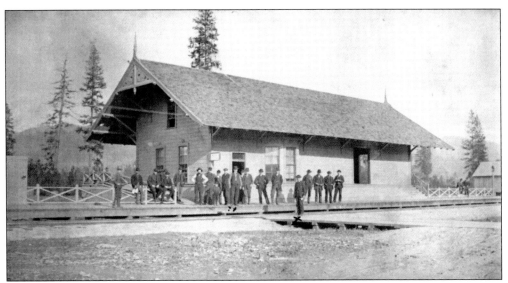

J.W. Howard stands off the platform and on the wall in front of the second train depot built in Grants Pass. The first depot was in the center of Sixth Street at G Street and impeded the flow of traffic on the street. This building was extended just a few feet into Sixth Street. J.W. Howard was the first businessman in Grants Pass to build a brick building on the southeast corner of Sixth and G Streets. In 1893, this building was put on a flat car and moved to Merlin, and finally Sixth Street was at full width at the tracks.

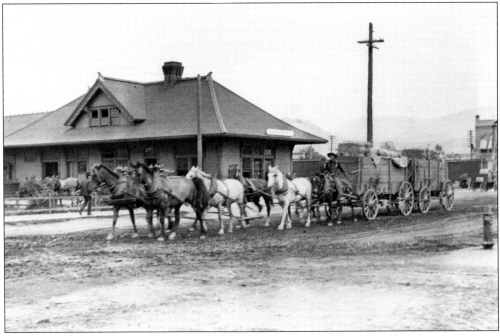

The third railroad depot stands west of the second depot site at Sixth and G Streets. A team pulling a double wagon moves south on Sixth Street. The driver is riding one of the horses for better control. Things to note in the photograph are the electrical poles, the fire hydrant to the right, and just above the hydrant, the spigot with canvas hose. This is the point where water was put in the steam engines.

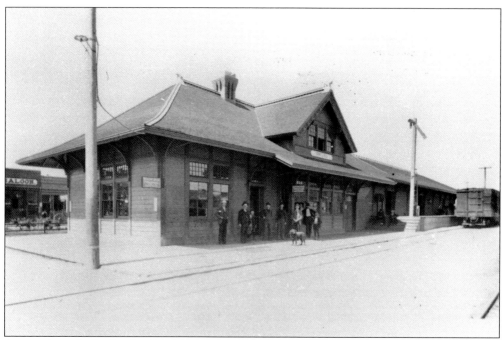

A view from the back side of the depot, now the freight depot, shows the large warehouse built to the west so that items received could be stored inside until they were picked up. Moving and storage became a business for some, including Fred Isham.

At the south end of Sixth Street, the second bridge on the site shows a surrey arriving in town. The bridge was constructed quickly when the 1886 bridge washed out during a flood in 1890. This wooden bridge stood until about 1909.

The longest single span in the world at the time of construction, this 1890–1909 bridge shows up in many photographs. The left-hand portion shows a small arch, which had to be added when the ground approach to the bridge washed out in a flood around 1893. The power plant and diversion dam can be seen downstream. Women and children pose for the photograph, and behind them, nets dry in the sun. A boat sails on the lake created by the dam. There was a marina where boats could be rented.

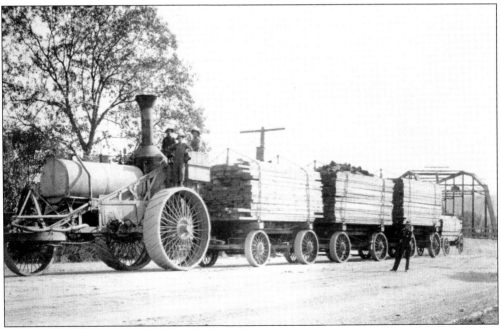

Crossing the third bridge, a lumber tractor pulls a giant load of processed lumber into the city. Large loads such as this were transported from the milling site to the construction site. County roads were not paved, and the tractors traversed the roadways with minimum damage. It was generally not a trip that could be made in the rainy season.

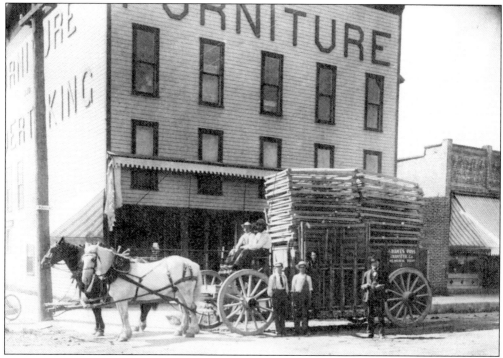

The furniture and undertaking business on North Sixth Street receives a load of bed springs. Obviously unwrapped and shipped as-is, the springs were picked up at the freight depot and transported to the furniture company by the Grants Pass Transfer Company.

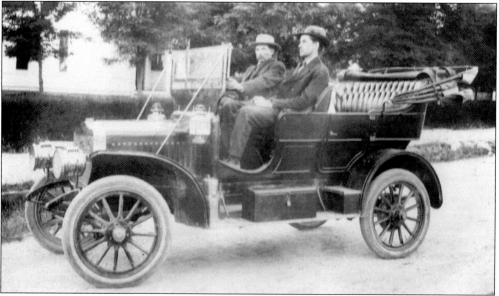

Photographed in front of the courthouse in March 1909, Jim Logan, the driver, and Frank Bruce Olding ride in a Maxwell automobile along Sixth Street. Olding was the Maxwell dealer in Grants Pass. Shown is a Model DA Maxwell that cost $1,750 and was a four-cycle, 30-horsepower vehicle. It came in dark green or red. Most automobiles at this time were packaged dismantled in large wooden crates and sent to the dealer by train.

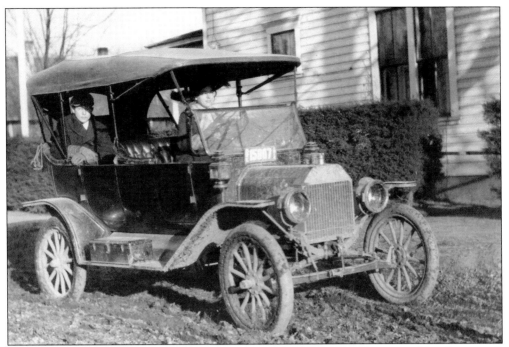

This 1914 photograph speaks for itself. A mother is driving her son along a muddy side street. It must be cold because both have on coats and gloves. The windshield is flipped forward so the driver can see better.

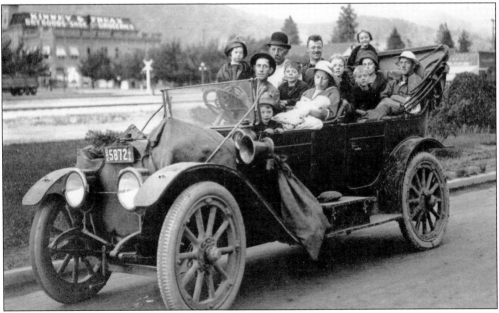

There are a dozen passengers plus the driver, who sits at the wheel on the right side, in this automobile. The railroad tracks and opera house are in the background. A suitcase is on the right side along with a small bush in a bag. A duffle bag is on the left-front fender, and on the running board are a utility box and sack of necessities for the drive, plus a rock to put under the wheel if they needed to stop on a hill.

103

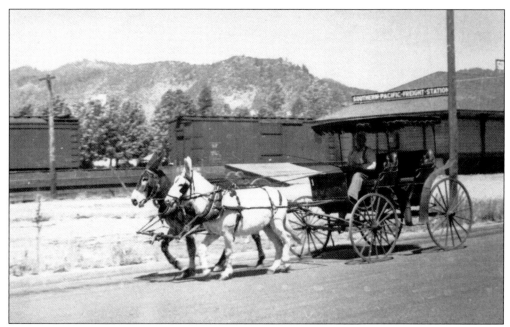

Fred Isham drives his surrey with the fringe on top along G Street with the freight depot in the background. This photograph is easily identified, but if no buildings were present, local residents could place the site because of the mountain in the background, which is commonly known as Beacon Hill.

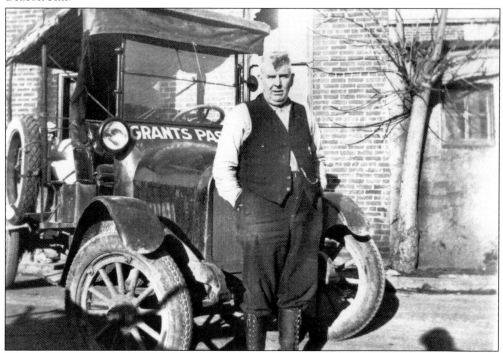

Fred Isham was the first businessman in Grants Pass to use trucks in his moving business. He is standing in front of one of his first "moving vans." Isham Moving and Storage was a long-lived business in Grants Pass, and the Isham family arrived early. There is a street named after them.

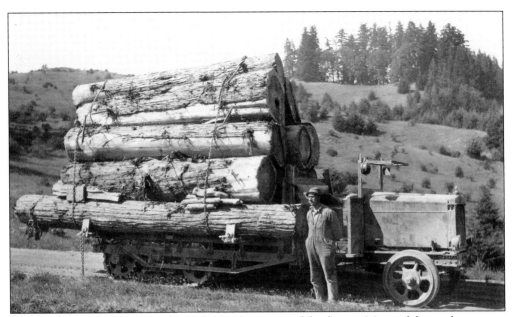

The first logging trucks carried large loads of trees out of the forests. Many of the roads were not paved and were not much of a road either, so a truck with rear tracks, not tires, could more easily haul the logs out on unimproved roads in muddy conditions.

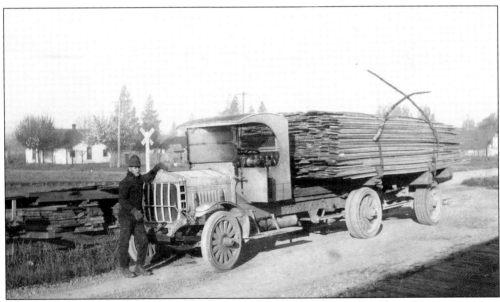

Milled lumber was transported from the mills by the first lumber trucks. This photograph, taken in 1919, shows the metal straps used to tie down the boards. The leather seat in the cab made the driving more comfortable.

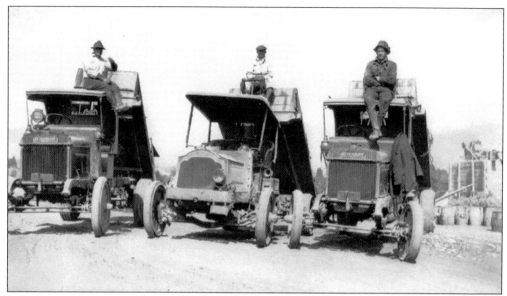

In 1913, Orchard Avenue was paved. Orchard Avenue was actually the northern end of Sixth Street. Proud of their modern road-building equipment, the three drivers pose on the top of their trucks. Names are not listed on the back of the photograph, but there is a comment that says, "A rose between two thorns."

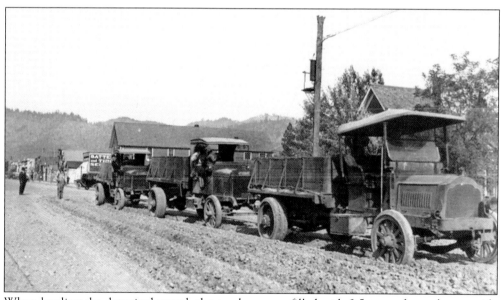

When leveling the deposited gravel, the trucks were refilled with 2.5 tons of gravel to provide downward pressure when dragging a clarifier over the gravel on the ground. The clarifier, not shown here, was dragged behind three trucks to get the job done, and the surface level, before blacktop was applied.

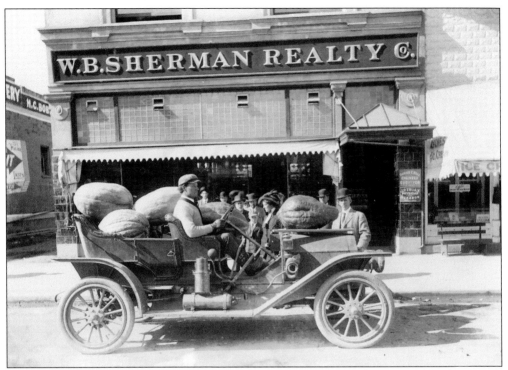

W.B. Sherman Realty was located next to the Coe Building on Sixth Street. This photograph was taken around 1911 when the Coe Building, to the right, was still a single-story brick building painted white. It burned in 1912, and a second level was added when it was restored. The subjects of the photograph are the giant pumpkins and huge Hubbard squash on the hood.

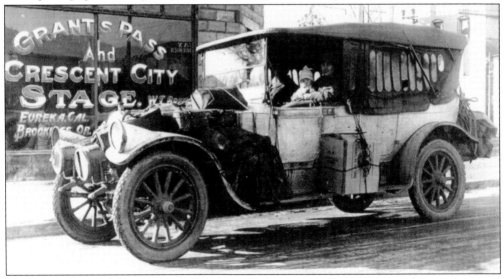

The Grants Pass and Crescent City Stage was the forerunner of bus service and the replacement for horse-drawn stagecoaches. Automobiles and buses are still called stages in some areas. For a nominal fee, a person could purchase a ticket to Crescent City. This endeavor was one of the reasons for the demise of the Oregon & California Coast Railroad, because people and packages could be sent by automobile after the road opened, and the train was not needed.

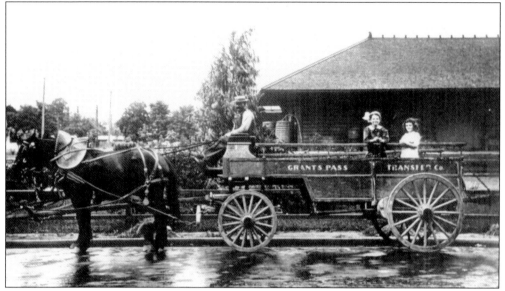

Horse-drawn vehicles and internal-combustion automobiles commingled on the streets from the first auto in 1904 into the 1940s. Sometimes the cost of feeding a horse was much more economical than the cost of a motor vehicle. Teenagers actually rode horses to attend Grants Pass High School into the 1940s and boarded the animals at a stable on Orchard Avenue and walked the few blocks to school.

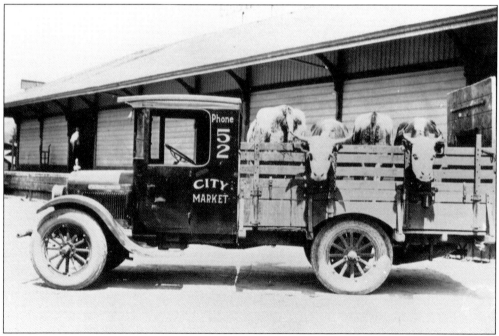

When phones came to Grants Pass, not many needed to have one in their house, but businesses needed the contraption to deal with other businesses. The first phone numbers were doled out in the order requested, and two-digit numbers were the first to be given. Before standardization of phone numbers, some early phone users had two, three, or four-digit numbers and sometimes a letter. The City Market truck sits by the railroad depot, and the cattle await their fate.

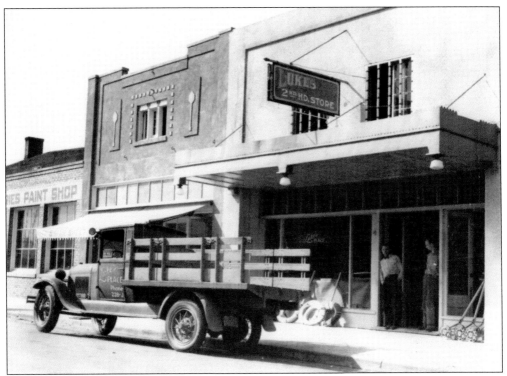

In 1930, trucks had become more modern and more in use than oxen, mules, and horses. Luke's Place, a second-hand store, was located on the north side of H Street between Fifth and Sixth Streets at 512 H Street. This was before the street numbers were adjusted. When this photograph was taken, numbers between Fifth and Sixth Streets were 500s, and those between Sixth and Seventh Streets were 600s. Luke's handled used goods but also repaired cycles.

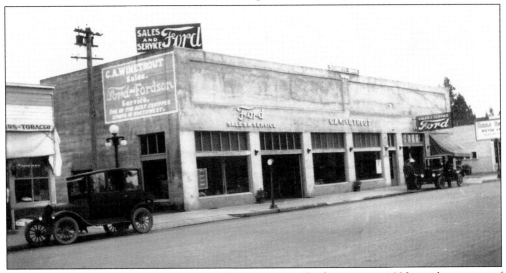

The Schmidt Brothers Building housed the Winetrout Ford agency in 1923 on the corner of Sixth and K Streets. Winetrout was a Ford dealer in Grants Pass for over three decades, starting at this site, then moving to H Street between Fifth and Sixth Streets, and back to Sixth Street at the northeast corner of I Street.

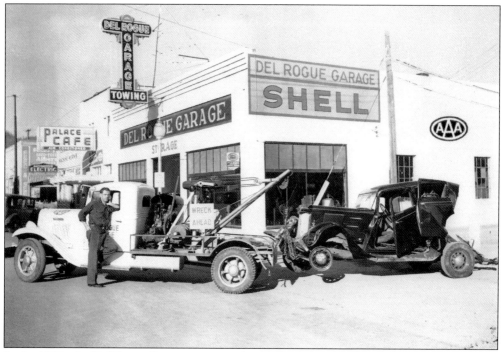

In the 1930s, the Del Rogue Garage was near the southeast corner of Sixth and K Streets, across from the Hotel Del Rogue and next to the Palace Café. It was owned by Howard Lowd.

An excursion train from San Francisco arrived in Grants Pass on May 5, 1890. There were banners on the side of the passenger car and a large crowd to greet the train. The event was photographed from both sides. In the background, at the corner of Sixth and F Streets, the opera house stands to the east, but the bank, built in 1890, has not even been started, and a wooden building stands on the spot.

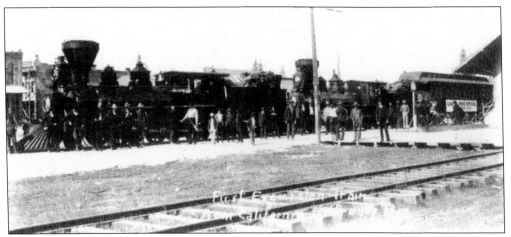

If one looks past the front locomotive, the first brick building, constructed by J.W. Howard, can be seen to the left with the Sherer-Judson Building, which had the year 1889 on the four small cupolas at the roofline, in the background. In this photograph, the building has not been completed. Scaffolding still stands at the front, and there is no glass in the windows. Evidently, it was a bit behind schedule.

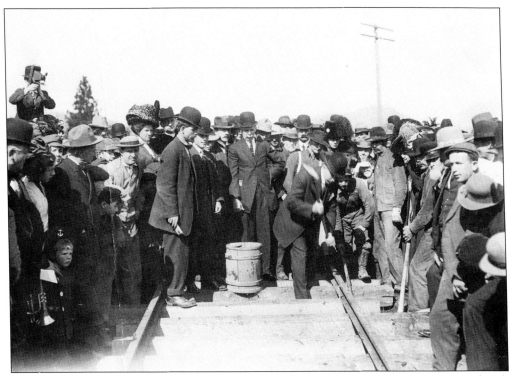

On March 1, 1911, the railroad from Grants Pass to Crescent City, California, was started with the driving of the silver spike. Stores and schools closed to attend the celebration. Each dignitary got to strike a few blows at the silver spike. The sad reality is that the railroad only made it to Waters Creek from Grants Pass and only 12 miles east out of Crescent City. The total length was to be 91 miles, and in total, only 28 miles were completed.

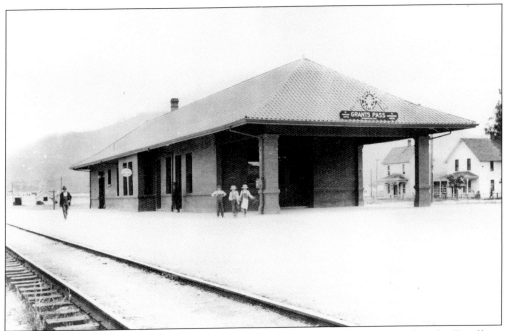

There were three train depots on Sixth Street near G Street in less than a decade. Finally, a passenger depot was built at Eighth and G Streets, and the old depot became the freight depot. The passenger depot was redbrick and would have lasted much longer if railroad passenger service had not been discontinued through Grants Pass in the 1950s.

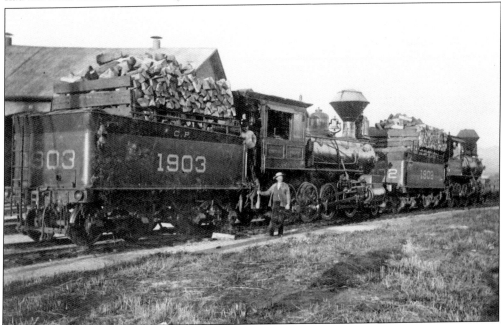

There was a roundhouse in Grants Pass after 1916 and engines could be turned around. Because some runs ended and began in Grants Pass or an extra engine might be needed to push a heavy load, there often were engines at the rail yard or parked on one of many tracks that were alongside the main line. This locomotive is facing east at the southeast end of the roundhouse.

The original Southern Pacific roundhouse and replacement stood at the corner of Fourth and F Streets. This is the first roundhouse, and all that remains is a piece of cement with the year 1916 engraved on the surface. The stacks of wood were used for the wood-burning locomotives.

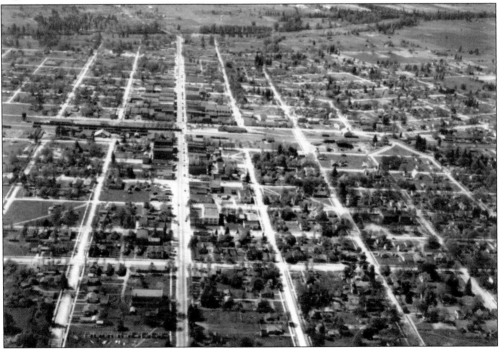

Looking south over Grants Pass with the nearest cross street, A Street, found at the bottom of the photograph, the entire business district can be seen as it was around 1928. The wide street is Sixth Street, and to the left, the passenger train station can be seen. Note that Eighth Street and Seventh Street are not through streets and are blocked at the railroad. On the right, the freight depot can be seen. At the corner of Fourth and F Streets is the roundhouse. At the end of Sixth and Fifth Streets, the old Grants Pass Diversion Dam diagonally crosses the Rogue River.

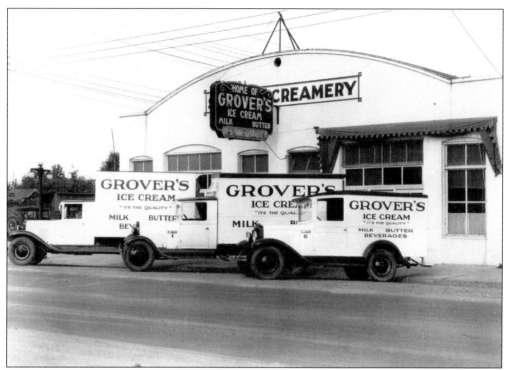

Grover's Creamery was located on South Sixth Street, first located at Sixth and M Streets. Grover's received the first Coca-Cola bottling franchise in Southern Oregon in 1927. The company operated the creamery, the bottling company, and the Grants Pass Ice and Storage Plant on the corner of Seventh and F Streets adjacent to the railroad tracks. In 1945, the creamery was sold, but the company continued bottling Coke products until 1957.

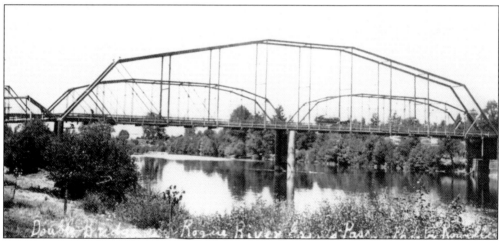

Around 1908, the construction of a steel bridge next to the old single-span bridge was started. Both bridges stood side by side for a few months before the old bridge was removed. By 1909, the new bridge was the only one standing. It stood until 1931, when Caveman Bridge was built, and the old one was taken piece by piece by truck downriver to become Robertson Bridge.

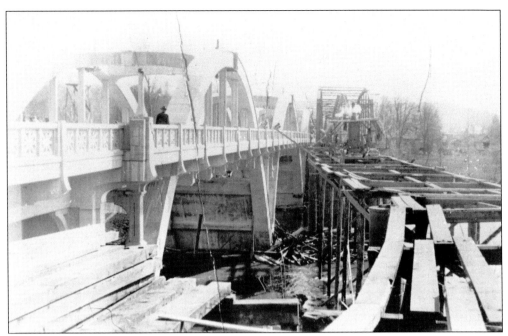

In 1931, the old wooden-decked steel bridge was removed. Note the deck planking dropped into the Rogue River. The new bridge, the fourth one on the site, had a new name, Caveman Bridge.

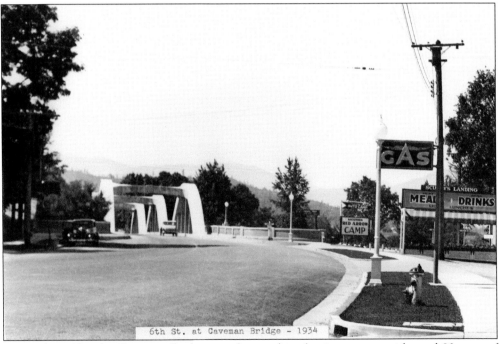

Pictured in 1934, the Caveman Bridge was almost white, having not yet withstood 80 years of internal-combustion engines and their exhaust. Scullys Landing was an auto camp and café at the west side of Sixth Street.

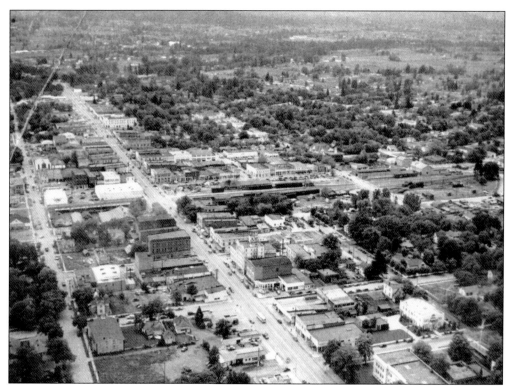

Photographed about 1941, the city center of Grants Pass shows growth and change. The roundhouse was gone, but the turntable remained. The new J.C Penney's building at Sixth and G Streets and the new Safeway store at Fifth and H Streets show growth in the downtown area. There is an intersection at Seventh and G Streets because the street was opened across the tracks and several of the tracks have been removed. Note how much the trees have grown.

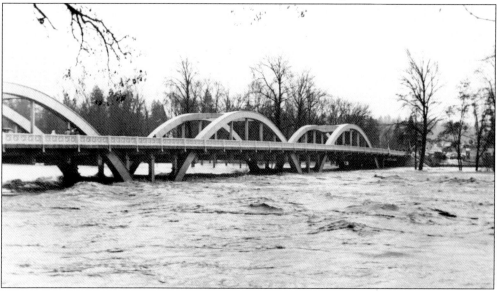

Not quite as shining white as when it was new, the Caveman Bridge holds its own against the floodwaters of the Rogue River in December 1964.

Six
PARADES AND GATHERINGS

Life was once centered around family, church, and local events. Grants Pass was founded in an era when things were rapidly changing in how people dealt with each other and with government. Instead of having a demonstration in front of some institution, people advocating something that caught their fancy just had parades and carried signs. Looking at the photographs that follow, one can see that Grants Pass had a bit of everything.

In 1908, a Rose Parade was instituted but did not survive long. A parade was planned when the fair was in session. If a circus or rodeo came to town, there was a parade. The Fourth of July and Labor Day were occasions for parades. The gladiola growers started to have a parade with floats covered with gladiolas. That lasted until the Boatnik parade was established; by then, gladiolas were not a big business, and the Memorial Day weekend Boatnik parade replaced the August Gladiola parade. There were Christmas parades as Santa came to visit for awhile before his busy day. There were even funeral processions down the center of town, which were sometimes accompanied by marching soldiers if the deceased was a veteran.

Until 1941, there were empty lots between Sixth and Seventh Streets along the tracks on G Street. The area was known as Railroad Park and was the terminus of most parades that ran north from the river. Politicians passing through on the train would pause at Railroad Park and give speeches. Balloons were launched from the site during July celebrations. There was a bandstand that served as a stage for logging demonstrations, speeches, and concerts.

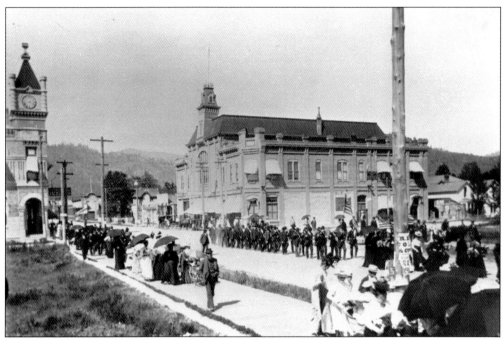

Early parades generally moved north and ended at Railroad Park, unless it was a circus parade. Demonstrations generally went the opposite direction, whereas funerals went in the direction of the cemetery. This procession in 1898 may be of a funeral parade. It is proceeding south across the railroad tracks.

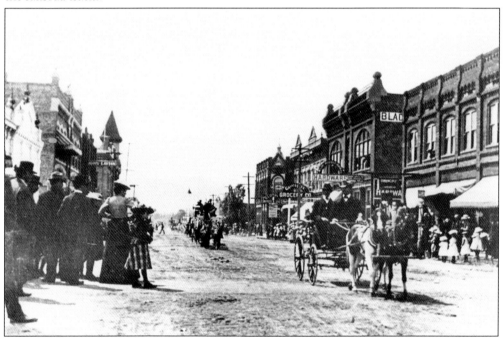

A parade prior to 1910 moves north on Sixth Street. Casual dress had not yet been developed, and all the viewers were well dressed. Note the group of young girls at the lower right. They all have on black leggings, white dresses, and pinafores with white hats.

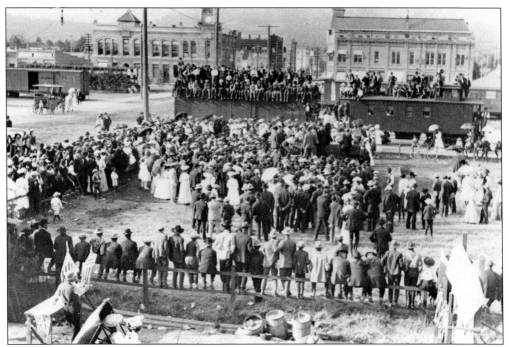

A crowd gathers at Railroad Park on Sixth Street to watch a demonstration on the band stand. Railroad Park had no trees and little grass because the crowds gave little chance for grass to grow. This is where politicians would make speeches from the back of their campaign trains, where balloons and Fourth of July fireworks were set off, and where people came to see lumberjack demonstrations and listen to bands play.

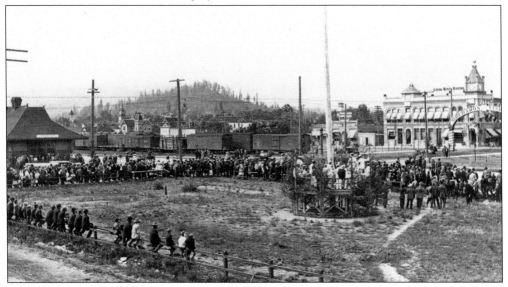

Much of the crowd is looking northeast, including the men on the bandstand. This was the site for the launching of balloons. Maybe that was the event for this day. In the foreground to the left is the railroad freight depot. In the background the Methodist Episcopal steeple can be seen, and the steeple to the right is the Presbyterian church. To the right of the flagpole, the bell tower of Central School can be seen above the office of the *Oregon Observer* newspaper on F Street.

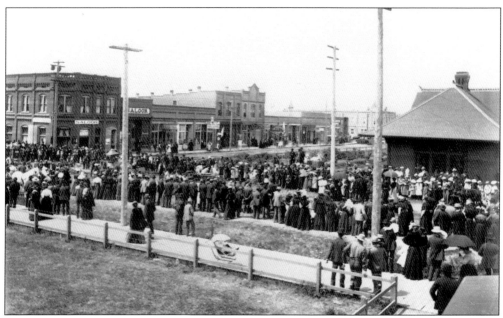

When there was a celebration with a parade in Grants Pass, the citizens would congregate at Railroad Park for other activities and move to Sixth Street for the parade. Three men are raised above the crowd in front of the freight depot. They are probably speaking about something of interest. It may have been when prohibition was proposed by the city. This photograph was taken prior to 1908 because the saloon signs are still displayed and the town went dry in 1908.

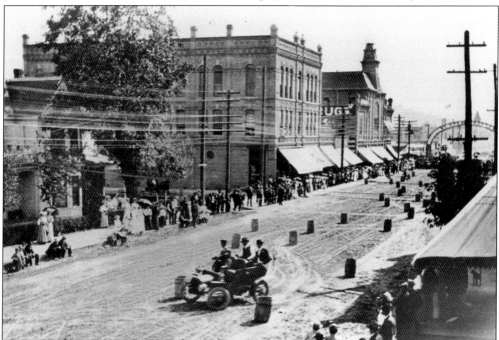

An automobile demonstration is given around 1907. The hospital is to the left of the photograph, and people are sitting on the second-floor outdoor balcony. Grants Pass had a hospital in many places. Most were short lived. Note the power lines.

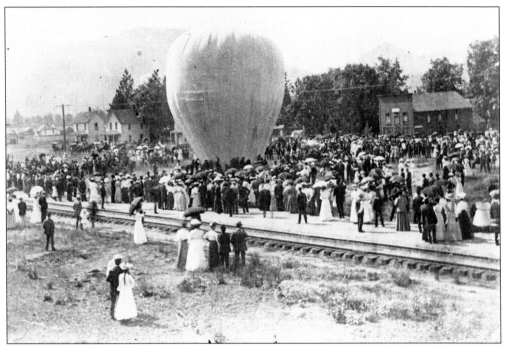

One unique form of entertainment was the hot-air balloon. On this particular occasion in July 1907, a daring aerial navigator performed tricks on a trapeze hanging below the balloon and then parachuted to the earth. This photograph was taken in the 700 block of G Street, which means at that time it was between Seventh and Eighth Streets. Neither of these streets crossed the tracks in 1907, and the end of Seventh Street is behind the balloon.

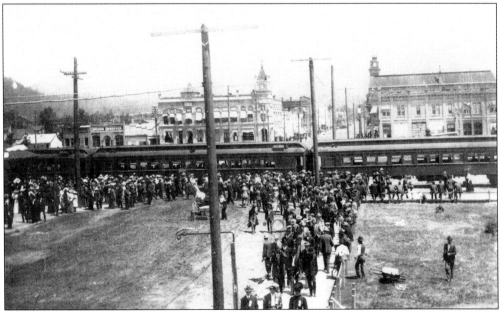

William Jennings Bryan's campaign train made a whistle stop in Grants Pass in 1907 when he was running for president. It looks like the speech is over as people are walking away from the train.

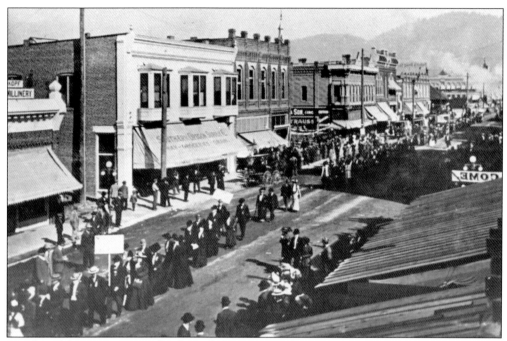

A political demonstration walks through Grants Pass about 1908. Steam from a locomotive can be seen in the background just where water could be added to the train's boiler. There are many women in the group, so the demonstration may have been for the right of women to vote. After six attempts, Oregon gave the right to vote to women in 1912.

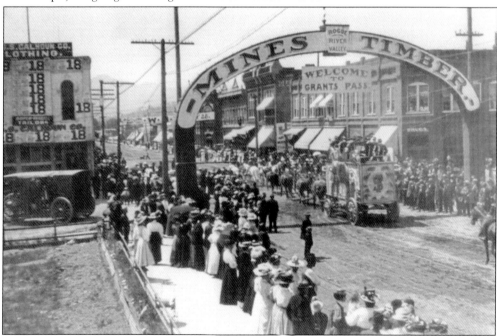

A circus parade passes the intersection of Sixth and G Streets prior to 1910. The large "18s" on Calhoun's store are posters advertising a Wild West Show, which was scheduled to appear in Medford.

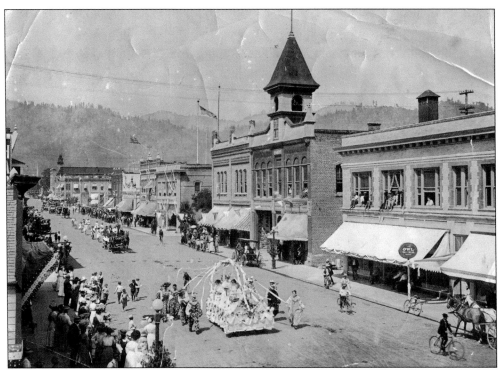

This photograph, taken in front of the city hall around 1908, shows a float with clowns and wagons pulled by horses, followed by some of the earliest automobiles in town. Note the people sitting on the window ledges and the little kids following the clown float.

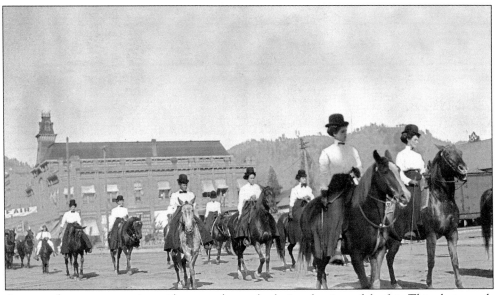

A group of women equestrians ride across the tracks during the time of the fair. This photograph was mailed as a postcard on November 29, 1910. The back of the card states: "Dear Marcela, I will write you a letter in a day or two. We are doing much gadding about. This is the way we looked during the fair. The bald faced pony got the prize. Pony is not so pretty as mine. B.B."

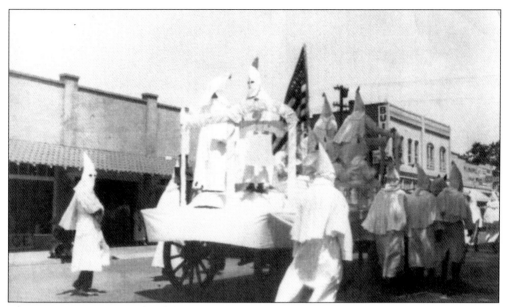

There are many photographs of the Ku Klux Klan parading in Grants Pass in the 1920s and 1930s, and at times, they even entered floats in the parade. This photograph was given to the Josephine County Historical Society in 2010 by an elderly gentleman who wished to remain anonymous. The circumstance of the photograph was that his father was a clansman. His mother was taking photographs, and just as his father passed by, the little boy yelled out "Hi, Dad." When his father (left) turned to look over his shoulder, his mother snapped this photograph.

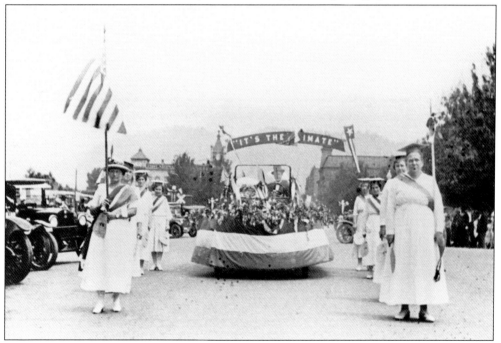

Suffragettes march in a 1920s parade either asking for the right to vote or celebrating the passing of the Constitutional amendment granting the right to vote. The "It's the Climate" sign in the background dates the photograph to around 1920.

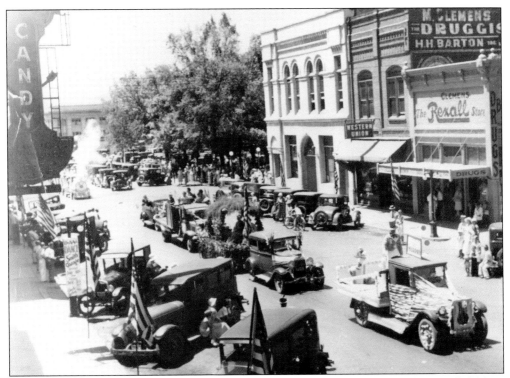

The Fourth of July Parade in 1936 was also called the Rose Parade. Rose Parades were held for a period of about 20 years from about 1907. Eventually, the parade was phased out in favor of the Gladiola Parade.

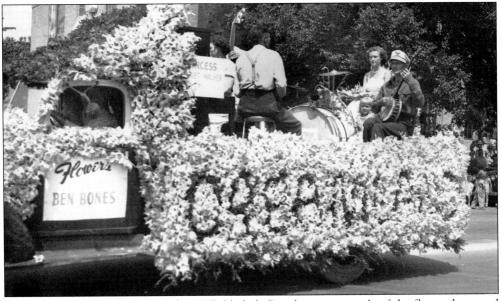

The Ben Bones gladiola float in the 1947 Gladiola Parade is an example of the flower-decorated floats that appeared in the parades. Growing gladiola bulbs was a sizeable business in Grants Pass in the 1940s and 1950s. Ben Bones was the first commercial gladiola grower. Before the bulbs were harvested, the fields were cut, and spears of the flowers were used to construct floats.

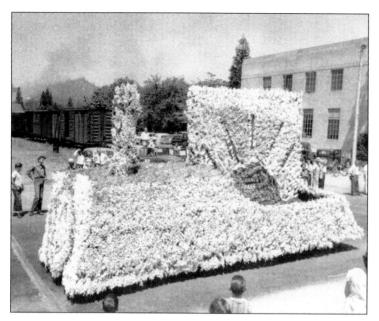

The Boatnik Parade eventually replaced the Gladiola Parade. The gladiola floats were difficult and time consuming to build and cover with the flowers. Volunteers worked on them for a couple of days before the parade, hoping they would not wilt too much before being driven down Sixth Street. After the parade, the floats were displayed on the football field at Grants Pass High School or Riverside Park.

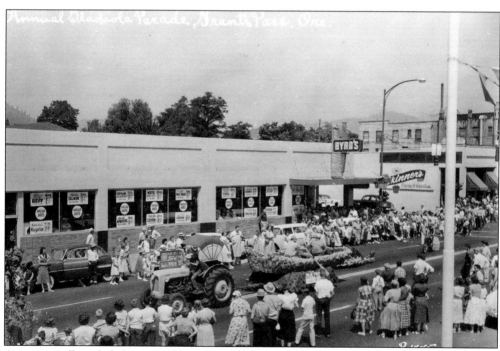

A tractor pulls a gladiola-covered boat past Byrd's Market at the corner of Sixth and L Streets. The market existed as Mac's Market, Kampher's Market, and then Byrd's Market. These parades were the highlight of the summer months, with a queen and her court chosen in the spring. The young ladies made appearances in many parades in Southern Oregon, culminating with the local Gladiola Parade.

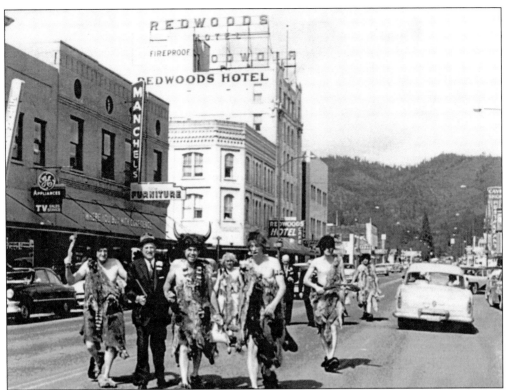

With the Redwoods Hotel as a backdrop, the Oregon Cavemen walk in the center of Sixth Street. This was not a parade, but the Cavemen were inducting someone as an honorary member of the Cavemen. Many people, famous and not so famous, were given the honor of becoming a Caveman, including Richard Nixon, John F. Kennedy, Robert Kennedy, and Shirley Temple.

In the early 1940s, a pageant was held in Grants Pass. Jeanette Spencer Dickson gave this photograph to the Josephine County Historical Society and all she remembers about the occasion was that she was a bumblebee and wished she had been selected to be a butterfly because they had bigger and prettier wings.

Discover Thousands of Local History Books
Featuring Millions of Vintage Images

Arcadia Publishing, the leading local history publisher in the United States, is committed to making history accessible and meaningful through publishing books that celebrate and preserve the heritage of America's people and places.

Find more books like this at
www.arcadiapublishing.com

Search for your hometown history, your old stomping grounds, and even your favorite sports team.

Consistent with our mission to preserve history on a local level, this book was printed in South Carolina on American-made paper and manufactured entirely in the United States. Products carrying the accredited Forest Stewardship Council (FSC) label are printed on 100 percent FSC-certified paper.